New York Institute of Photography
100th Anniversary

TOP TEN SECRETS FOR PERFECT
BABY&CHILD PORTRAITS

A QUICK-AND-EASY EVERYDAY PHOTOGRAPHY GUIDE™

D0048239

CLAY BLACKMORE

ALLWORTH PRESS
NEW YORK

This book is dedicated to Monte Zucker, Joe Zeltsman, Phillip Charis, and Paul Linwood Gittings—four great friends, great cameramen, and great teachers. I admire their work, and I work to rise to their levels of achievement.

12 13 14 15 16 17 18 19 20 21 10 9 8 7 6 5 4 3 2 1

Published by Allworth Press
An imprint of Skyhorse Publishing, Inc.
307 West 36th Street, 11th Floor
New York, NY 10018
www.skyhorsepublishing.com and *www.allworth.com*

Copublished by New York Institute of Photography
New York Institute of Photography is a registered trademark of Distance Education Co. LLC in the United States and/or other countries
211 East 43rd Street, Suite 2402
New York, NY 10017
www.nyip.com, blog.nyip.com, and *www.decnyc.com*

Cover and Interior Page Design by Keith Gallagher
Editorial Writing by Sarah Van Arsdale
NYIP Publisher: Jay Johnson
NYIP Director: Chuck DeLaney

Library of Congress Cataloging-in-Publication Data has been applied for and is on file with the Publisher.

ISBN: 978-1-58115-994-3
Printed in China.

CONTENTS

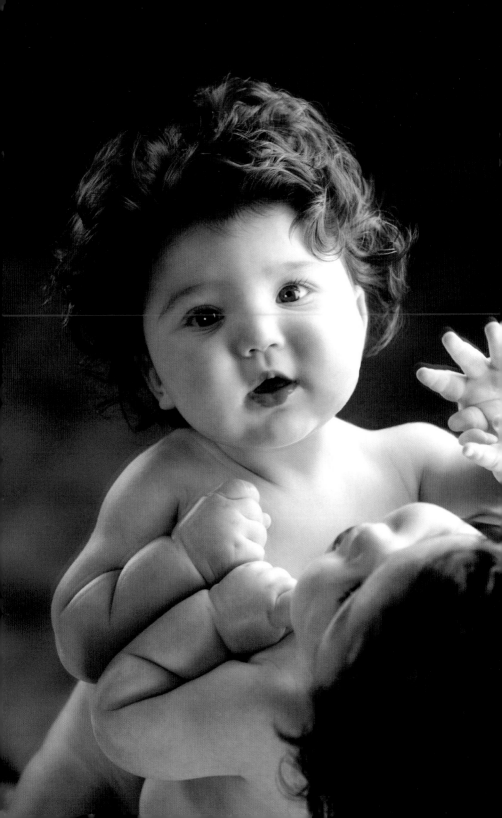

WHY YOU'RE HERE

This Everyday Photography Guide™ is all about my favorite saying, "confidence is key." It certainly applies to photographing babies and children. By the time you're finished reading and working with this book, and learning all the tips and secrets professionals use to produce jaw-dropping portraits, you're going to feel more confident about creating great images—all by yourself.

Confidence comes from success, and success comes from practice. Photography is like any other hobby or profession; to succeed requires practice and dedication. First, you'll learn the basics of taking great baby and child photos. You'll start to understand lighting and posing your young subjects, and practicing all the techniques that are essentially "secrets" to parents, grandparents, guardians, and other non-professional photographers.

My mentor, Monte Zucker, went to his teacher once a week for ten years to learn how to properly pose and light his subjects. Monte

A sheet of mirrored glass with nice smooth edges is a great way to make portraits of little children who can't walk yet. They're fascinated with their reflections, and in the adult world, mirrors never lay on the floor within crawling distance. Let's explore!

became one of the best portrait photographers in the world, but he didn't get there accidentally.

I'd like you to practice the secrets of taking great baby and child photographs until your hands form unbreakable patterns. With practice, the how-to-take-a-good-photograph part of the process will become second nature to you.

And that's why you're here. Once the techniques become second nature to you, you'll be free to concentrate on your subjects and their needs. You'll be free to build an emotional connection with babies and children as you photograph them. That's the greatest secret there is to taking the best portraits and casual photographs.

The result of learning and practicing these secrets: your photographs will come from the *heart*, and your attention will be focused on creating warmth and strong connections with your adorable little subjects. That's the alternative to constantly thinking about what you should be doing technically.

THE KEY PROCESS BEHIND THE SECRETS

- Learn the basics.
- Begin to practice the basics.
- Practice until the techniques become second nature to you.
- Practice until your hands know the techniques by heart.
- Practice the Secrets as passionately as a doctor or a professional athlete practices their respective crafts.
- Open your heart to your subjects; focus on making a strong emotional connection with them while taking their picture.

Yes, I've repeated "practice" four times. On purpose!

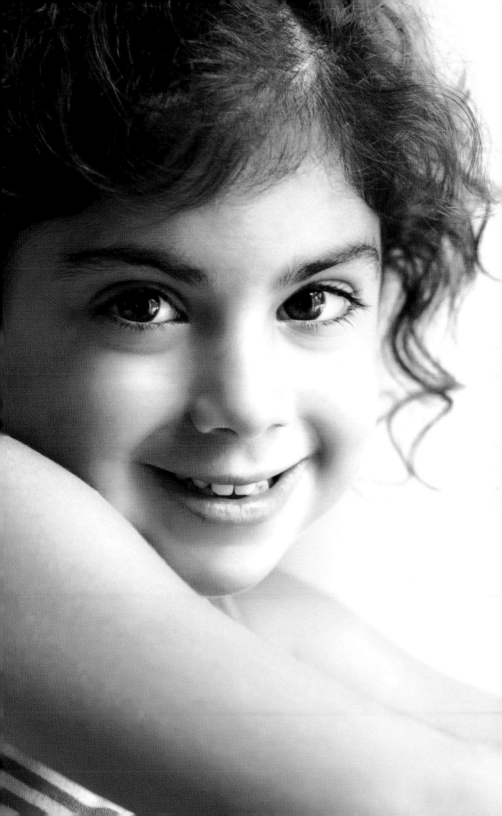

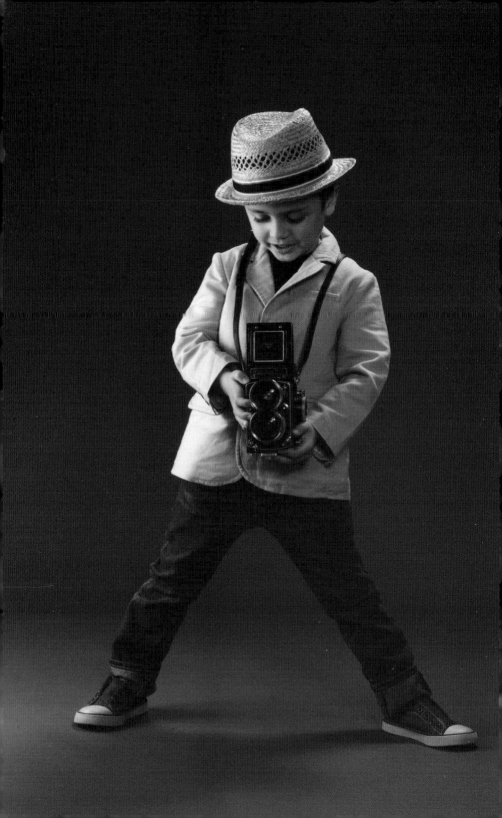

PHOTOGRAPHING CHILDREN

THE LONG TRADITION

You may think that photography was invented just for the purpose of keeping memories of your own children and grandchildren, and you're right that this is likely the most important reason why you own a camera. And we'll be telling you how to take better portraits of those little darlings than you've ever thought possible.

By learning and practicing the techniques that I've learned and practiced over the years as a professional portrait photographer, you'll be joining the long line of child photographers who have brought their gifts to the world through their photographs—even if you just take pictures of the children in your own family for pure enjoyment.

Photography has changed enormously since it was first invented. Today, it's a process we take for granted: we can snap a picture and send it to the other side of the globe in seconds. But it wasn't always so easy, and photographing children wasn't always a happy event.

There are lots of reasons for making portraits in black and white rather than color. Sometimes it's out of necessity, when your subjects are in colors that would distract from the photograph. But it also gives the portrait an older, classic feel and focuses attention on your subject's features.

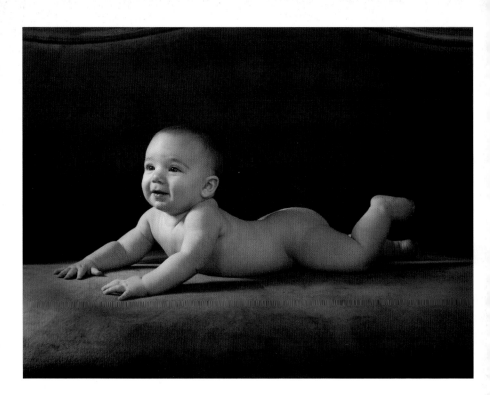

Until 1839, when the daguerreotype was invented, capturing a person's likeness was a complicated, rare occurrence. Before that innovation, people who wanted to be commemorated in image had to pay a hefty price for an artist to paint their portrait. But with the daguerreotype, a whole new way of creating portraits came into being. It's a way that now seems clunky, drawn out, and expensive, but at the time it was remarkably simple and inexpensive.

One of the first types of child photography was something we find unspeakably eerie today: images of children who had just died. In the Victorian era, as photography was beginning to become popular, infant and child mortality rates were high, and post-mortem photography, especially of children, became the way that many people created a permanent memory of their lost children.

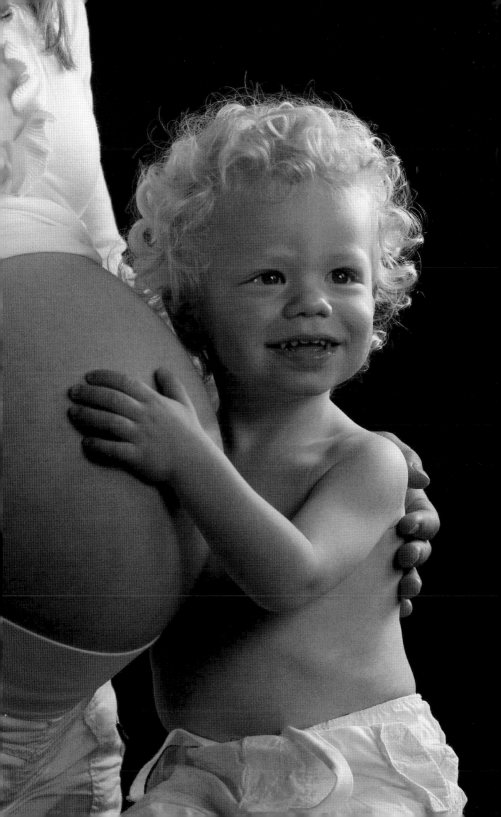

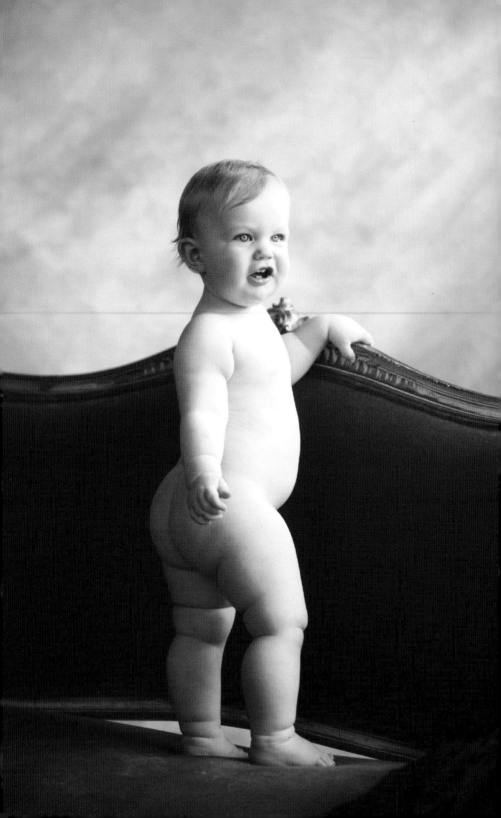

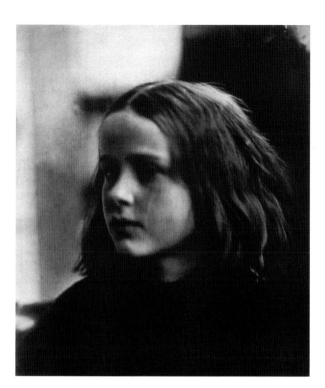

I've gotten a lot of posing mileage out of this green felt couch (see opposite page and pages 69 and 101). Whether placed in the studio or toted outside for portraits, it's a hit with kids who aren't allowed to stand on the furniture at home—it adds to the wonder and surprise of my photo sessions. A low back and unobtrusive arms make certain sofas great for posing youngsters.

Until the mid-1900s, most photography of children was formal to the point of being staged, with children posed as miniature adults. That was a reflection of the limitations of slow films, long exposure times, and how children were viewed by the culture. One of the best-known early photographers who focused her lens on children was Julia Margaret Cameron, who staged both children and adults as angels, saints, and characters from mythology.

Later still, in the 1950s and '60s, many of the most widely published photographs of children were taken by Diane Arbus, who specialized in photographing people at their very oddest, and Sally Mann, who was openly criticized for using her own children in her art photographs, often in seductive and semi-nude poses.

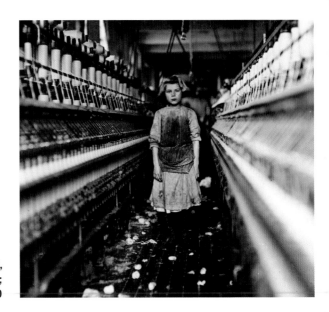

**Spinner in Globe Cotton Mill,
by Lewis Hine;
Augusta, GA, 1909**

CHILD WORKERS

From 1908 to 1912, Lewis Hine worked as an investigative photographer for the U.S. National Child Labor Commitee. He documented children as young as three years old working long hours in factories, mines, and fields. His haunting photos are among the most famous images ever taken.

But this darker side of child photography in the art world was balanced by the runaway popularity of photography among everyday people: parents, grandparents, guardians, relatives, and friends who were discovering that photography was not a mysterious, difficult process. It was something that could be done by anyone.

As early as 1888, George Eastman put forth the Kodak slogan, "You press the button, we do the rest," but it would still be decades before Mom and Dad or Grandma and Grandpa were tossing off candids of the kids with the kind of aplomb that seems natural to us today.

The continued streamlining of camera equipment meant that more and more people could take photographs with confidence, and without special training. The Polaroid Land Camera, introduced as early as the 1940s, allowed the photographer to take a picture and immediately see the image develop—a precursor of today's digital immediacy.

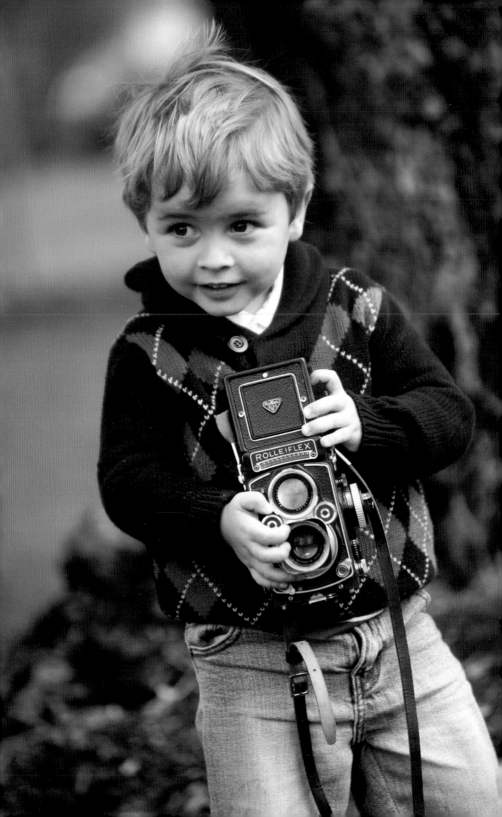

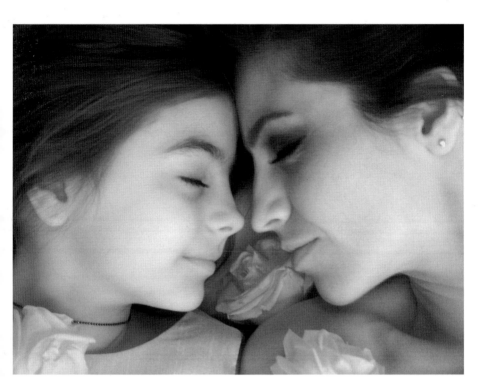

The 1950s ushered in the era of the family camera. Inexpensive models became a staple in every middle-class home in America. Kids were more often than not the subjects, whether in more formal scenes taken at a birthday party or more candid photos, say at the beach or riding bikes around the neighborhood. The class photo also came into being at this time: those shots of a group of kids in rows, the front row seated, arranged by height, shot from such a distance as to make each one equally unrecognizable.

School portraits of individuals also became popular in the 1950s and '60s, with each child shot under harsh studio light, with a smudged-looking blue backdrop, making each child equally unattractive. These official portraits are part of "assembly line" portraiture that I'd like you to banish from your head forever. This is *not* the kind of baby and child portraits you'll

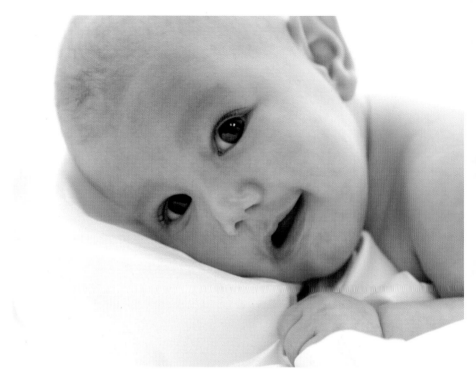

be taking from now on! Today, of course, photography—espeically of children—has become ubiquitous, with the advent of digital cameras and cameras built into cell phones, SmartPhones, and tablet computers.

And yet, for all the highly efficient, and often inexpensive equipment we have today, no one is born knowing how to take good pictures. So let's begin with the first of our *Top Ten Secrets for Perfect Baby & Child Portraits:* Getting the Right Attitude.

Since 1910, the New York Institute of Photography has trained over five generations of photographers. Visit NYIP at *www.NYIP.com* and follow the latest developments in the world of photography at *blog.nyip.com.*

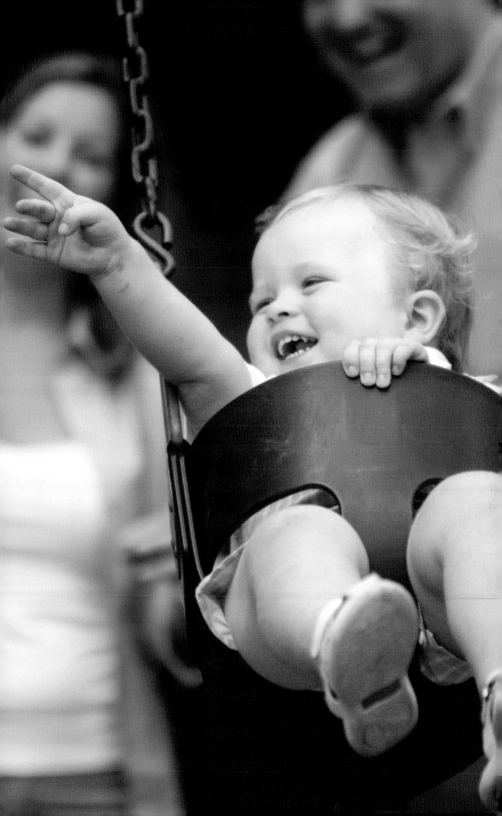

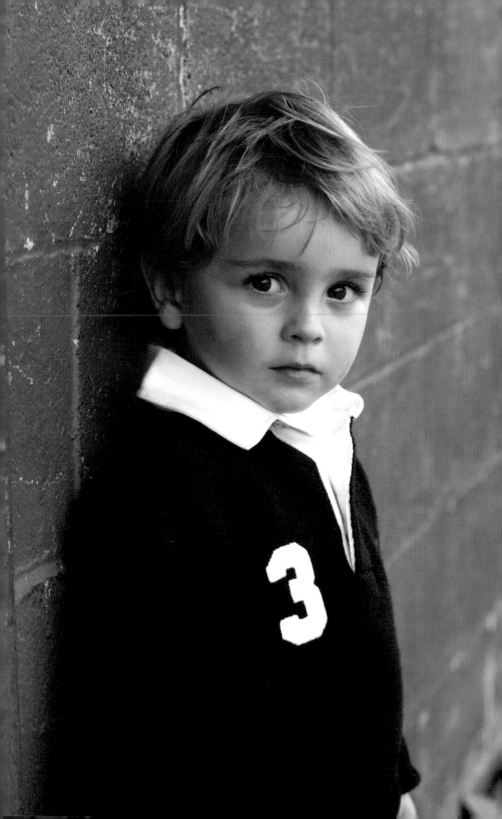

BE BOLD

ATTITUDE IS EVERYTHING

This is one of the most important rules to taking great pictures: you've got to be bold. You have to decide you're going to take some great photos of your baby or child, and you're going to jump in there and get them. This means:

- You're not going to be shy!

- You're not going to wonder if you're doing it right!

- And you're just going to get right in there and take those photographs!

A positive, bold, can-do attitude is especially important in photographing children and babies because youngsters may be shy or they may be cranky or they'll feel like, "Hey, I don't want to do this."

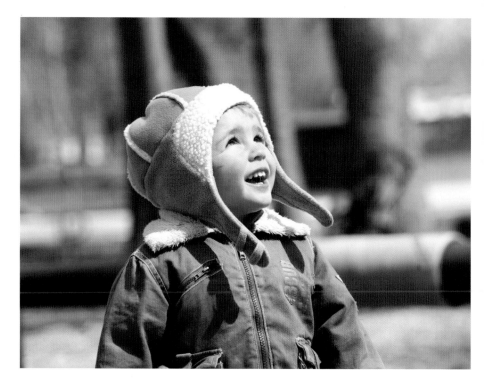

So the minute you take the camera into your hands, you're the catalyst in every situation to create the Perfect Portrait of your child. You must actively take the photo session into your own hands, and make up your mind that you're going to get the *greatest pictures of your life* in this session.

I tell parents, grandparents and guardians to take lots of pictures, to really get in close to their young subjects, to pull out and get far, and then to come back in and take medium-range photographs. In order to get those really great portraits, however, you just need to take lots and lots of pictures—and I can assure you that there will be that one … or maybe those two photos that make you say,

"Wow. I got it!"

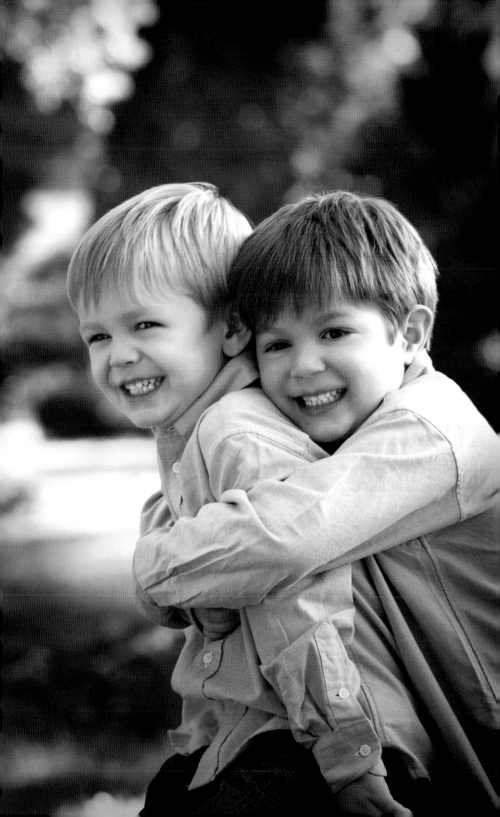

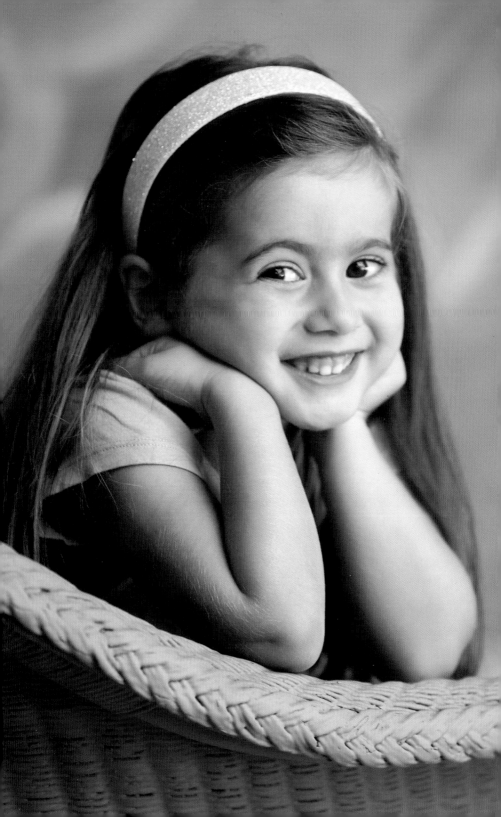

That's a major secret—and why I've called this Secret 1—to the whole process of taking perfect baby and child portraits. You need to have a "boldness of attack." Your attitude must be,

"I'm going to go in, and I'm going to take many perfect pictures."

And don't give your child (or children) any room to foil your Perfect Portrait mission. Be right in there with them. Tickle. Laugh. Play games. Some kids will respond right away; they're at ease, they're comfortable with having their picture taken multiple times, you can quickly get them into playing a game, and then you'll start to get the great shots.

But you can tell how some kids—maybe your child—might be a little shy, and so you have to play the Perfect Portrait game differently. Some children don't like to be tickled. Let's say you go in to tickle your child with a feather duster, and you can tell right away it isn't going to work. It's just going to make them cry, so then you tickle yourself, and you start acting goofy. Or you get your partner (this could be your spouse, your friend, or a close friend or relative) to stand near the camera, and say,

"I'm going to tickle Mommy."

And all of a sudden, you've got your child laughing and relaxing and having a good time.

Having a "boldness of attack" doesn't mean that you just jump in with your digital point-and-shoot camera and you set the shutter to click off as many photographs as you can get. It means really paying attention to what's going on with your baby or child—or now we can say, with your *subject*. (Yes, it's time

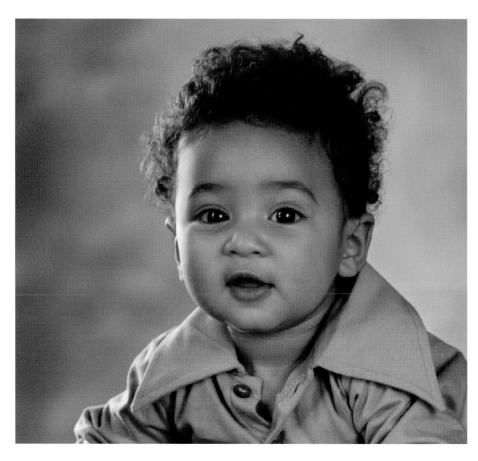

to begin to think like a professional photographer!) And why the rapt attention to your subject? You must follow your child's attitude and emotion so you have many opportunities to capture great images with your camera.

Get your child relaxed and laughing, and then hit the shutter. Get your child looking contemplative, and then you snap one shot after another. Pay close attention to your subject every step of the way.

It's up to you to make magic happen.

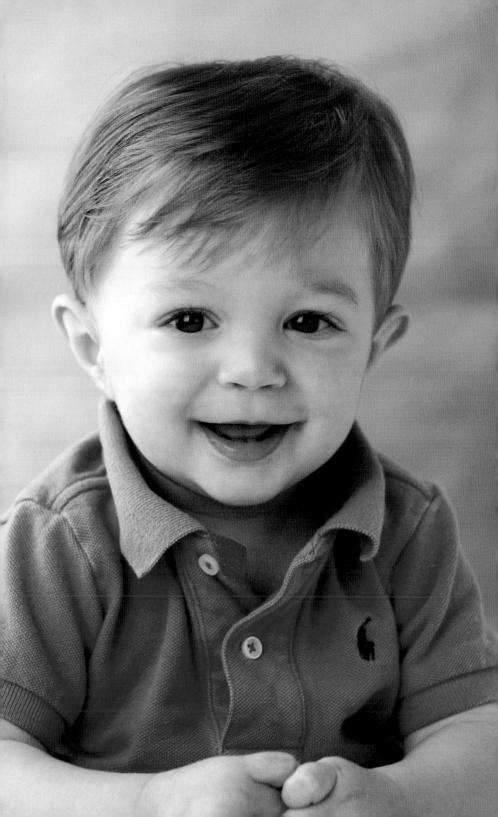

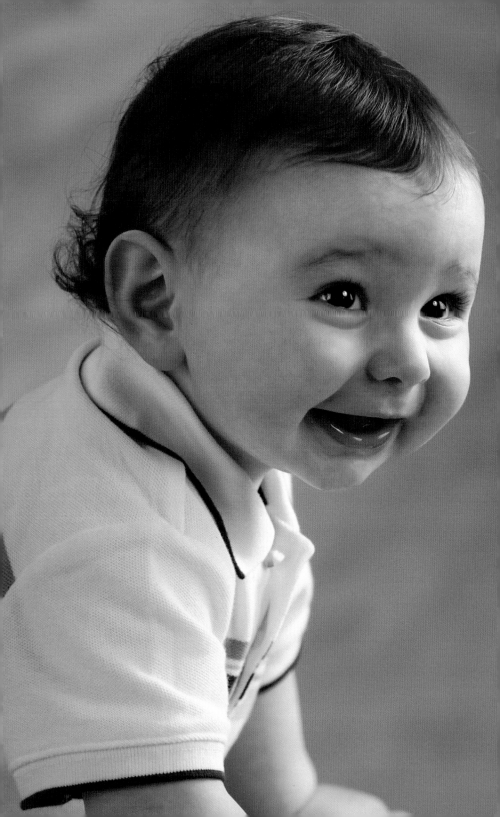

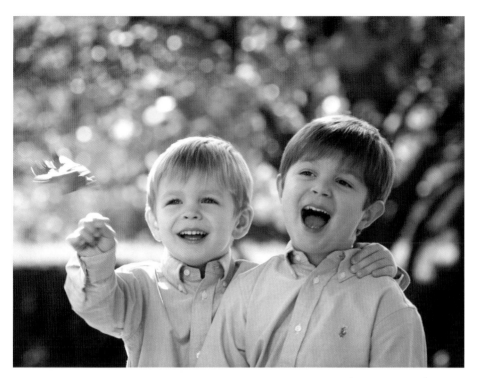

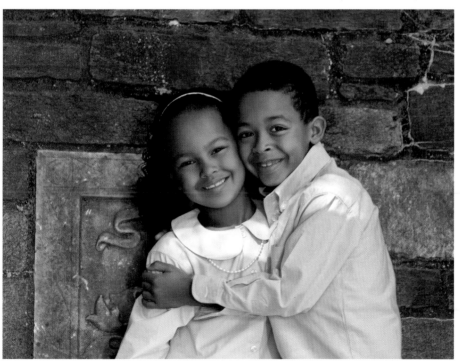

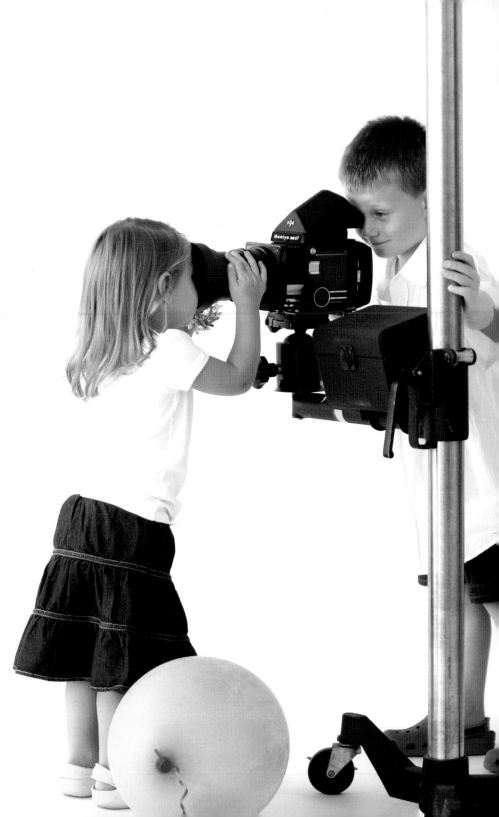

GEARING UP

GET THE RIGHT EQUIPMENT

It used to be that one person in the family had a "good camera," and then the Kodak Instamatic came along and the Polaroid— and now everyone has a camera on their phone. But SmartPhone pics won't help you take Perfect Portraits; you'll need to upgrade your camera to take really great portraits of the babies and children in your life.

Point-and-shoot or compact cameras have a little bit of a delay in them, and that's what most families own. You might later on consider purchasing a more updated SLR (Single Lens Reflex) camera that has removable lenses and faster shutters. Why? Children move a lot, so a little bit faster shutter speed is important. Having manual control will help a lot, too.

Take photos with the camera you own right now. You can always upgrade later.

Just consider that new DSLR (Digital Single Lens Reflex) cameras are more responsive, and they have a host of other great features.

- Better quality lenses for sharper pictures
- Longer telephoto lenses to help you zoom in closer to your subject
- Faster lenses that perform better in low light

In short, a DSLR camera will give your portraits superior quality focus and image sharpness, and these are both hallmarks of the Perfect Portrait.

Your local camera or electronics store will have trained personnel that will be able to recommend specific camera manufacturers and models in a price range that fits your budget. Ask friends and neighbors, as well as other family members, for their recommendations, too. I like Canon because I've been working as a professional photographer for 25 years and I've always used Canon. I can personally vouch for the quality of Canon equipment.

For right now, use your current camera. But even at the entry level of photography, you'll need a few more equipment items so you can take the Perfect Portrait.

- Purchase a big silver reflector so you can catch the light by a window. I'll elaborate more on how to use a reflector when we talk about lighting in Secret 9.

- You'll need some furniture and a few props, but nothing you don't already have around the house. You can put the kids on your sofa, and if your furniture has a distracting pattern (or even just doesn't look that great), you can drape it in a clean white sheet, and that will give your portraits a more professional look.

It's important that the linens you keep as props are spotless. We launder ours regularly and store them in plastic bags to keep them dust free.

You don't need to have special background paper or the expensive lights you'll see in some of the photos in this book; you can wait until you're working professionally to get those!

One thing that's really helpful and that you may not think of in terms of "tools of the trade" is an assistant. It's helpful to have someone else working with you when you're taking portrait photos of adults, but with children, it's downright essential. You have one person holding the camera and taking the pictures, and the other person really working with the child, getting in there, making friends, getting the child to relax and laugh, and also getting your young subject to try to stay still when you want him or her to stay still.

With young children, it's also imperative to have someone close to the child at all times to prevent unexpected tumbles.

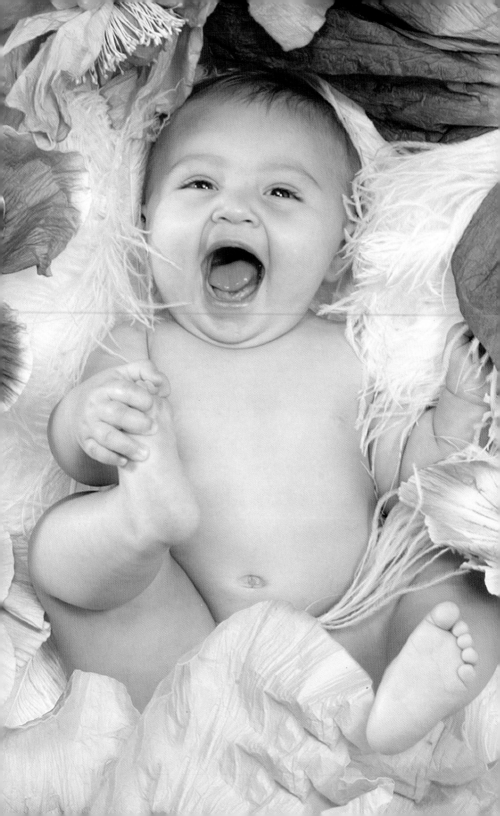

THE SILLY DILLY

DEVELOP RELATIONSHIP AND TRUST

Once you've decided on your "boldness of attack" and you have the basic gear to take the Perfect Portrait, you have to focus on getting your subject in the right picture-taking frame of mind.

As a professional photographer who comes into a client's home or sees parents and children in my studio, I'm starting out as a complete stranger to the child. I have to make friends with my subject, and get the child in the best possible mood.

The key is to have a photographer who has great rapport with the subject—and that's much more important than having a great camera.

Let's say I'm called in to photograph Toddler Jane Doe. I have to make friends with Jane, entertain her, but not talk down to her. This process goes on throughout the entire photography session. Children always know the difference between someone who's naturally inclined to play with them on their level and someone who's faking it by talking down to them.

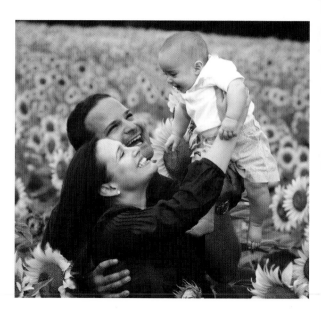

You're reading this book because you're going to start pursuing your new interest in photographing children and babies with those closest to you—your own children or grandchildren. And of course you're no stranger to your child! That's a *huge* advantage that you have over any professional.

But bear in mind that you must keep your advantage of rapport and genuine love for your child working strong during the time you're taking portrait pictures. Make it clear to your child that this time—this photo session—is going to be nothing but *fun*. This is going to be like going out for an ice cream on the first warm day of spring, going to the playground, or watching a favorite show on TV.

Make it clear that this is *not* going to be like eating spinach.

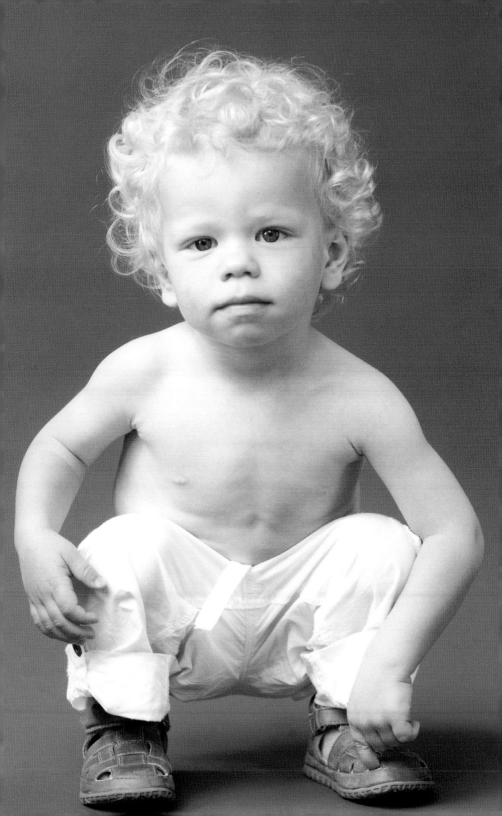

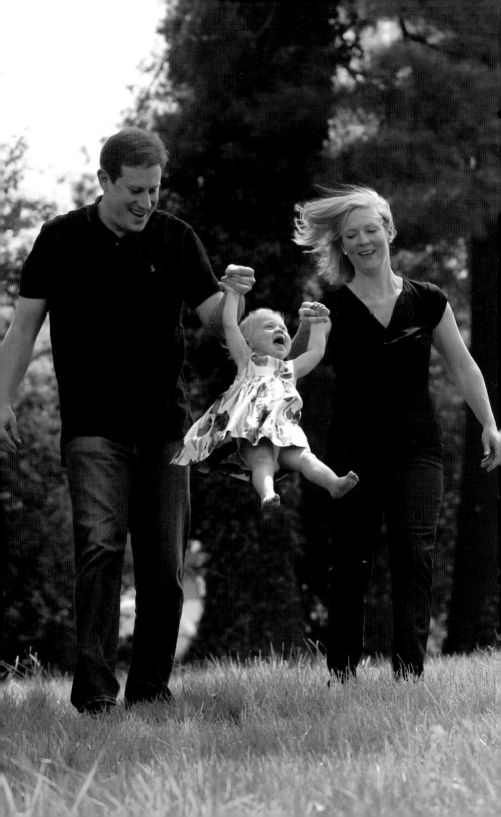

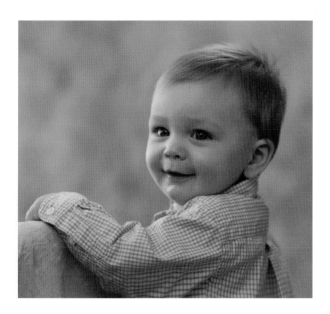

Whether you're photographing your own child or someone else's, you have to be patient. So many parents tell me I have the "patience of Job." It's important that you remain patient, too. You can't rush the photography process; it has to be on your child's terms. Realize that if the time you spend taking pictures is 30 minutes, that's great—but the entire photo session could take one hour and 30 minutes. You should allow *two hours*, and that way if you need the extra time, it's there.

As you begin photographing, I want you to get right down on your child's level. Get on the floor with her. Start playing games with her. You need to get as silly as you can. You want to get her happy and enjoying your fun time together. You want your child to think,

"Wow, Mommy is silly!" or "Grandpa is so funny!"

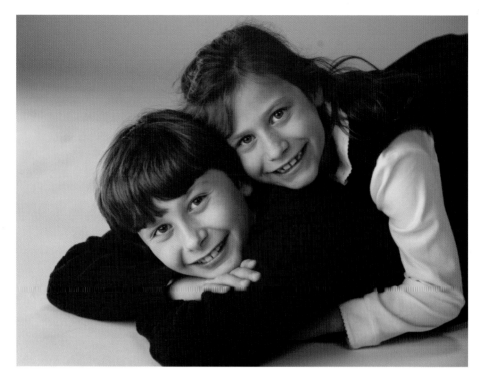

It's getting them to change their behavioral state—it's not going to be their day-to-day routine.

When you have this silly, great relationship magic happening, then you can start to take portraits together. But first, just be their pal. Anchor them in that fun-and-silly moment with you, make the posing and setup and shutter snapping fast, make it so that they don't even know what's going on, and all the while keep playing games with them.

"Let me guess your name. No, don't tell me—your name is Silly Dilly."

"I bet you're a doggie, aren't you? You're a boy doggie!"

When your child is having fun, your photos just sing.

For the child who's on the verge of walking independently, a chair can provide the perfect anchor of the few moments necessary to get the photograph.

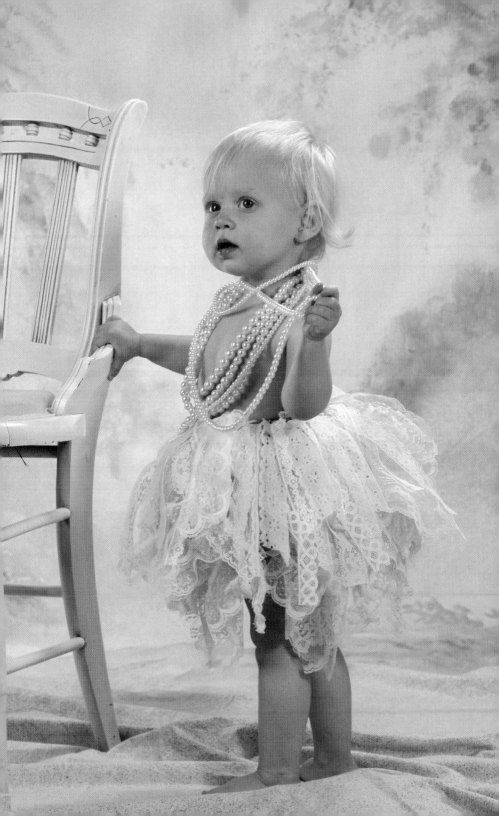

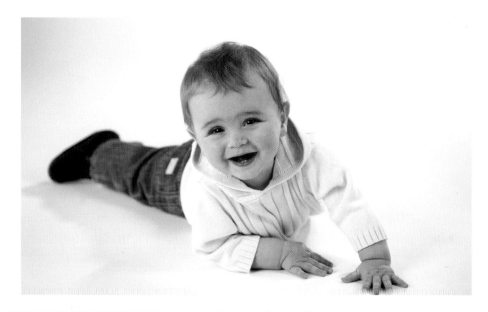

Here's a piece of lighting you might want to purchase in the future. This ring light provides a distinct flat lighting that doesn't have the pinpoint directionality of the pop-up flash on your camera. It's also a curiosity to any young child. Make it the origin point of interesting objects that appear almost within reach.

We've been talking about how to develop a trusting relationship with your young subject—and oftentimes it's best achieved when you play the Silly Dilly, game-playing clown. But you can also use enticing toys and props to gain your child's attention and get just the right image. You'll see here how my assistant reached through a ring light (which, to a child, is a pretty intriguing and fascinating lit-up shape by itself) and held a ball out to our subject. This is how we captured the marvelous pose for the first portrait in Secret 4 on the next page.

Our little boy has a perfect pose with his up-stretched arms and playful facial expression.

While you don't need to invest in a ring, have your assistant use a tempting toy or other prop to help your subject pose while you find the right angle and side lighting to take another Perfect Portrait.

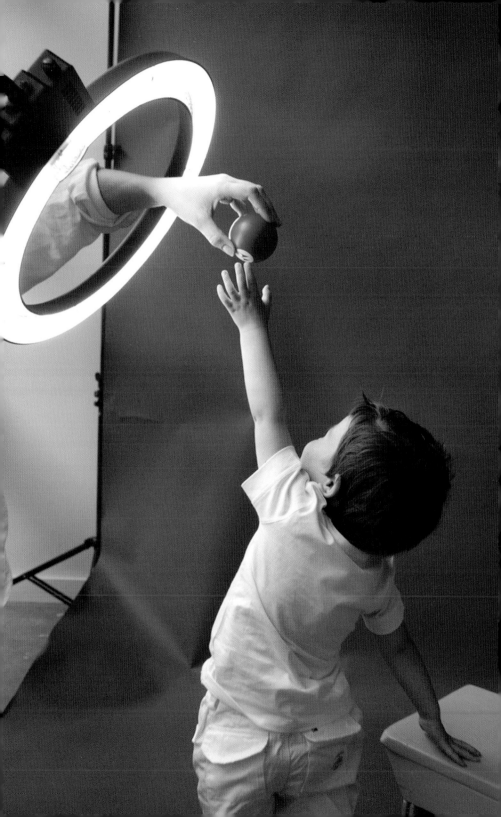

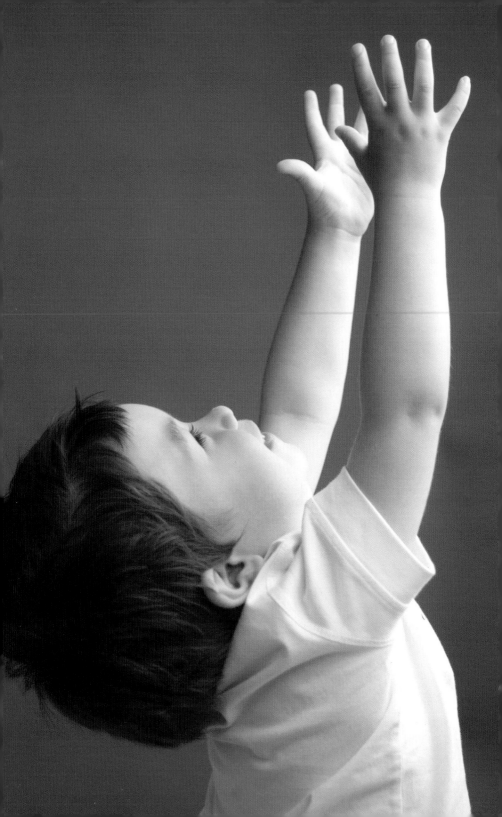

EARN YOUR CHOPS WITH PROPS

GET AND USE PROPS

I said that you need props, but to start out with, you don't need anything more than what you have around the house.

With adults, you just need a chair and a wall to take the most basic portraits. But with children, first and foremost, you need something to anchor their bodies. Unless your subject is a newborn baby, little ones move fast—he's here, he's there, and he's running around. You need a place for him to focus his energy, and you just can't tell him to sit down and be still. You have to make it interesting for him. (Again, back to Secret 3—keep playing games!)

So first, I use a posing block or a prop that helps me anchor my active little subject. There are several companies that make great posing blocks, which are just like wooden crates in different sizes. But to start, you don't have to buy anything special. You can use an ottoman or a pouf or a sturdy low table that your child can sit on. The object is to have something that anchors your subject and helps provide focus.

BABY PROPS

I've just found a company called The Design Revolution (*www .designrevolution -online.com*) that specializes in baby props ... like hats and buckets, small sofas, and tons of little outfits and accessories that I've found very useful in taking baby portraits.

Blocks, or block substitutes, are versatile posing tools. Use your imagination to seat your subject on a block. Use two blocks—have him sit on one and put his feet up on another. You can have him lean on a block. A cute look is to have a little toddler kneeling on the floor and leaning on a posing block—adorable!

Small clean blankets and sheets can also be used to accessorize the portrait or drape over your blocks. Just make the posing and anchoring fun for your child, and set your block(s) up in a place that's uncluttered and by a window (more on the importance of windows and lighting to come).

For a toddler, you can set him up so that he's standing behind the posing block, and then put an interesting new toy in front of him. You'll have his attention long enough to get in there with your boldness of attack and take a burst of photos to capture perfect expressions.

But getting a child, especially if he's a little bit older, to sit or stand still long enough to take the Perfect Portrait may require another prop … and it's something you have in your pocket right now! Here are the steps I take in this simple process.

- Take a quarter or a dollar, depending on how old the child is, and lay it on the floor.

- Tell the child, "Look, Silly Dilly, put your foot on that quarter. If you can hide that quarter from me, you can keep it."

- And then that foot is anchored, and they're stuck in the middle of the floor!

- Then I say, "Let's play Simon Says. Simon Says put your hands in your pocket." And that's the shot you're looking for! (Or, "Simon Says clap your hands." Or "Simon Says touch your ears.")

You can also get a child's attention by having a puppet talk back and forth with your child or you find a new game to play together— something *different and new* will really get your subject's attention.

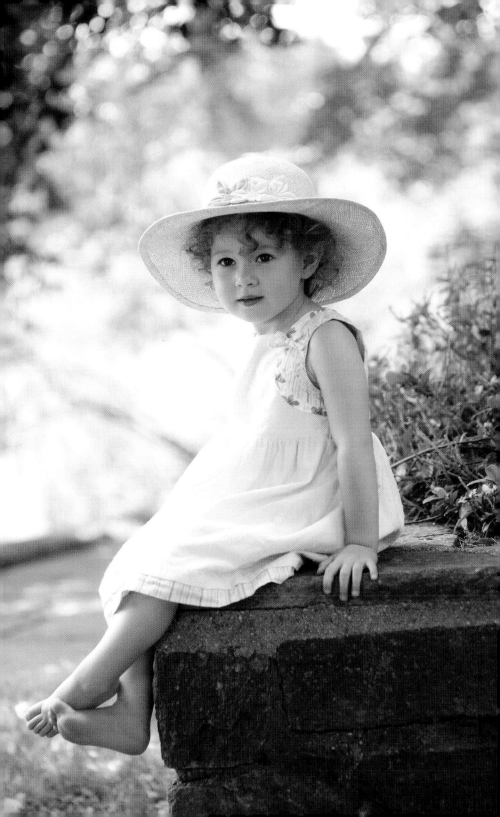

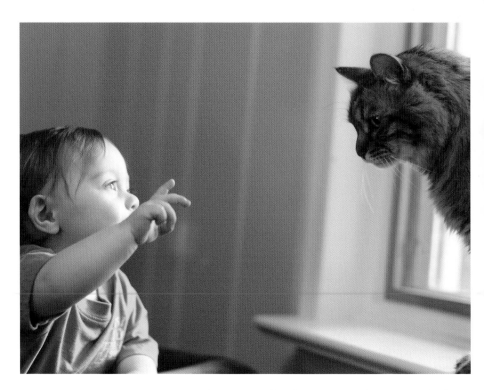

I make sure I also have some long-handled "ticklers," either a feather duster or a feather wand cat toy. These are great for tickling a child with enough distance so you can quickly pull back and take a picture of the child while he's still laughing.

For babies and very young children, to get their hands in a delicate, interesting pose, just take a bit of double-sided tape, and stick it onto their fingers. As the baby's trying to get it off, her fingers are posed delicately. When the hands are well placed, make a noise, watch the baby look up, and then press the shutter—you've got another Perfect Portrait.

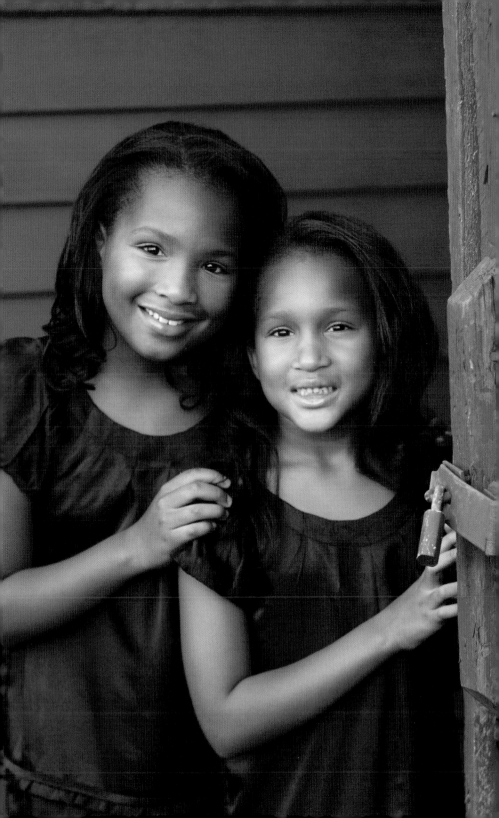

Don't forget to use food as portrait props. The cupcake store that we used for this mother/daughter portrait session is as cluttered as any home could be. Using a long lens and a large aperture allows me to throw the busy background out of focus. During a portrait session, it's okay to play with food, and I even ducked outside to photograph through the store window to capture them fooling around with treats.

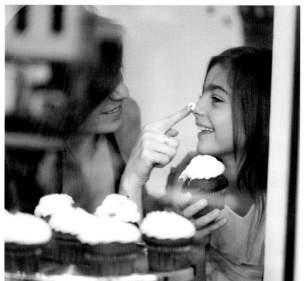

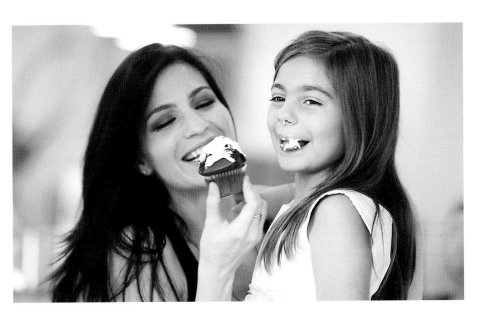

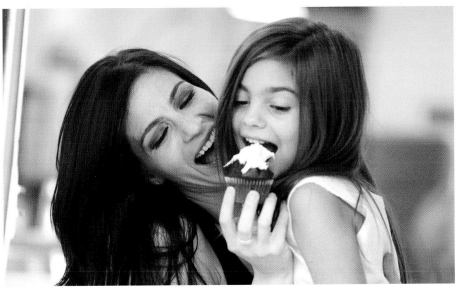

Photo © NYIP Student Cristiana Garcia

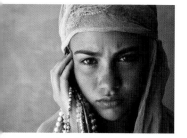

Photo © NYIP Student Michelle Milliman

Photo © NYIP Student Randy Basso

Enjoying the Book?

At NYIP, we know that a passion for photography is something many people share. That's why we published this book, and it's why we are dedicated to providing the highest quality home-study photo education in the world. We want anyone, no matter where they live, to be able to follow their dreams in photography and get the training they deserve.

If you're ready to take the next step, learn to become a better photographer, and even start earning money with your photography, then we're ready to show you the way.

Visit us online at www.nyip.com/book to request a free course catalog.

We promise to make you a better photographer!

"I highly recommend this course to anyone, even those who may be somewhat versed in the basics of digital photography. The audio and video presentations provided by the staff made the instruction more personal and made it feel like they were right in the room with you. Overall this course improved my picture taking, thank you NYIP!" **– William H., Indiana – 2010 NYIP Graduate**

AMERICA'S OLDEST AND LARGEST PHOTOGRAPHY SCHOOL

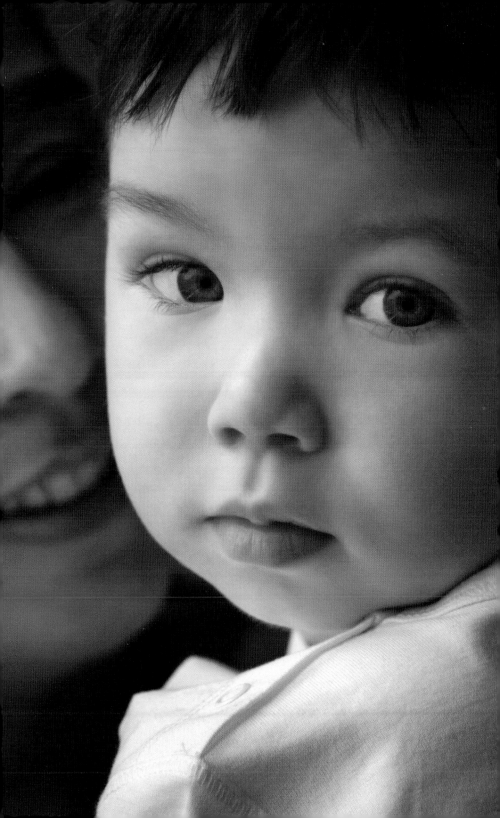

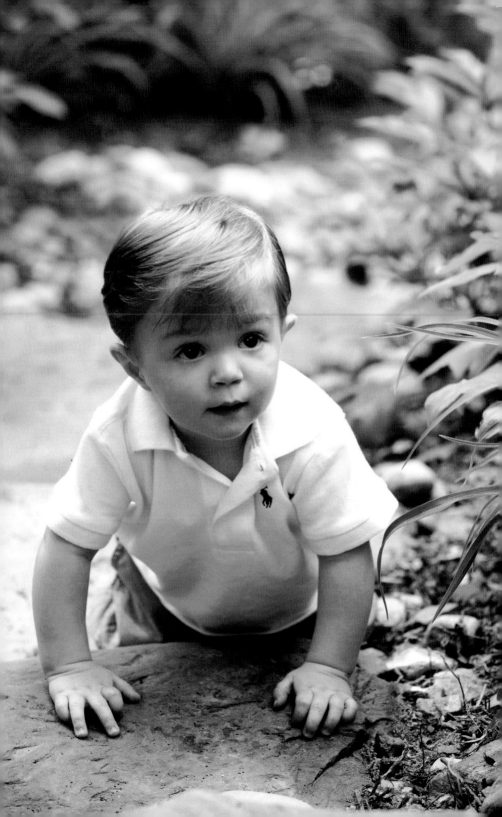

SECRET NO.5

BABY BRIGHT EYES
GET AND KEEP YOUR CHILD'S ATTENTION

Getting your child's attention long enough to take good pictures can be a little tricky. You want his attention, you want him to look at the camera, or you want him to look away from the camera for a profile—and yet you also want him to forget about the camera, to forget it's even there.

The secret to getting your child's attention is to get him to think about something. It's as easy as that. But you have to provide that "something" throughout your portrait session. You want to get your young subject so interested in something else that he forgets all about being your photo subject.

When you're working with very little children or babies, you'll need to work hard at getting and keeping their attention. They're busy little bees—they're looking over here, they're looking over there, and you want them to look right into the camera for some of your portraits.

So your boldness (Secret 1) will have to include a commitment to getting and keeping his

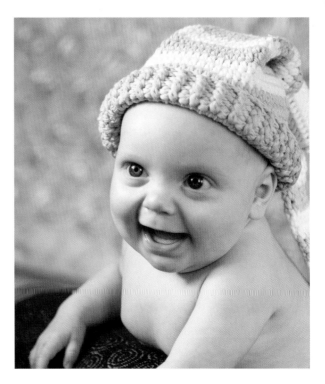

attention. Be realistic in your expectations, however. I plan on getting 4–5 minutes of good attention span from each young child I photograph. Sometimes I get lucky and wind up with 10–15 minutes, however that's about it for an entire photo session; the rest of the time is bonding and making friends and playing.

With babies, sometimes little noises will work to get their attention, but these sounds can't be loud enough to startle them. I recommend using a soft whistle, a little bell, or even a set of car keys or a ring of plastic toy keys.

First ring the bell or jingle the keys softly right by the baby's face. Get his attention, and get him to focus in on the object in your hand. Then bring the bell or keys right above the lens of your camera so your baby can track the sound and look almost directly at the camera.

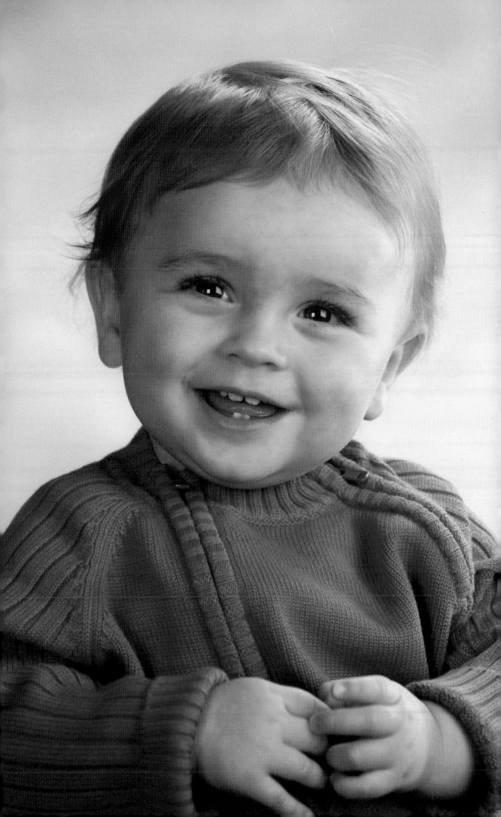

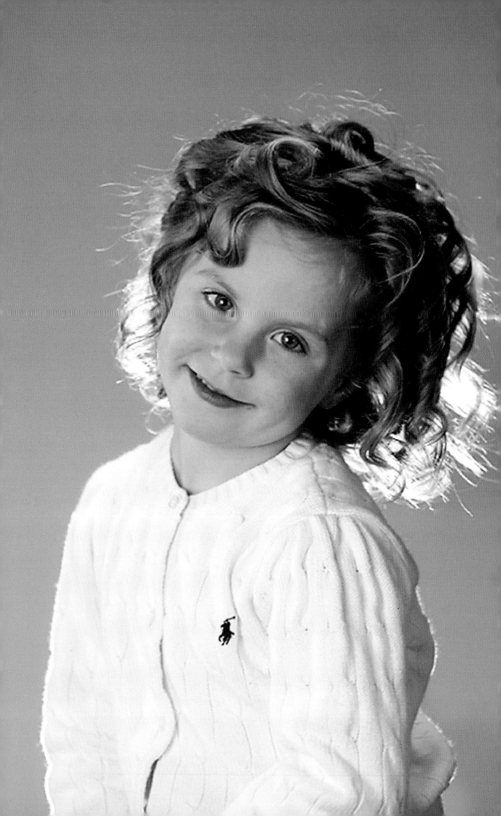

Now, take your Perfect Portrait! Your baby's picture will show bright eyes—or, in professional photography terms, you'll see *catch light* or reflected light in his beautiful eyes.

Sometimes your baby will just be looking down, preoccupied with something on the floor. Start ringing the bell or jingling the keys, get Baby looking at the bell or the keys, and work the object in your hand back towards the lens of your camera. Then snap!

If your baby is having a very shy day—or maybe you're photographing someone else's child—you might have to have your assistant or the child's parent, grandparent, or guardian relax the baby while you work from a distance, taking photographs with a long lens.

Getting an older child's attention comes back to developing a relationship with him. If you're taking photographs of your own child, you're there already! But if your subject is someone else's child, then you've got to start from square one.

A favorite attention-getting technique to use with an older kid is to play a guessing game.

Say, "I'm going to guess what you had for breakfast. Don't tell me!" or "I bet I know what color your bike is."

He'll pay more attention to you than if you just said, "What did you have for breakfast?" The guessing part turns it into a game. Your subject's not even thinking about you, and he's lost all the tension he'd normally have in front of the lights and camera.

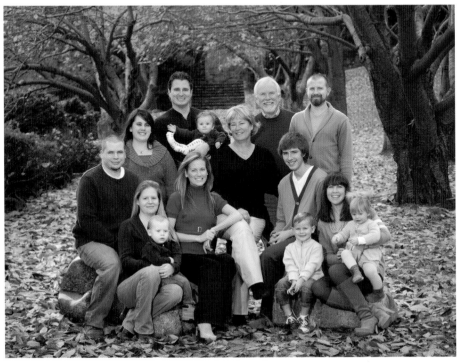

SECRET NO. 6

POSES HEAD TO TOES-ES

ALL ABOUT POSING

Y ou want your child to sit or stand still, but you don't want her to have this tortured look on her face like she's suffering through a photo shoot. Your goal: find a creative way of making her pose and be still.

Your child is naturally on the move, so you've got to get her on a little chair, on a block, on a little plastic rock. The key is to anchor her so she's not going to be moving everywhere. Unless you're prepared to take freeze-action motion shots, you won't want her to be moving around. Get her anchored down, and then go to work.

But if all you do is anchor her, that's going to last for 3–10 seconds—unless you entertain her. Keep her "stuck" there long enough to get in with your boldness of attack and photograph her great expressions.

The posing block and other block substitutes that I mentioned in Secret 4 on props will help with posing: position your child behind one, leaning on it, sitting on it, or one child leaning and one child sitting—whatever feels and looks fun and natural. The blocks-and-anchoring strategy will give you a lot of versatility. With a small child, turn her so the body is at an angle.

For posing babies, if they're between a newborn and three months old, there's not much support in her neck, so we have baby posing devices or special baby props. Sometimes I'll lay the baby on the mother's knees and come in for a close-up picture. Sometimes I'll lay the baby on a baby blanket,

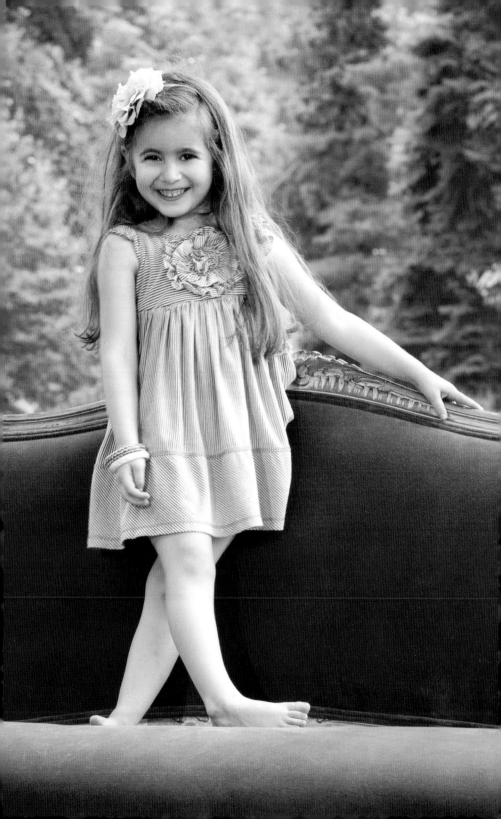

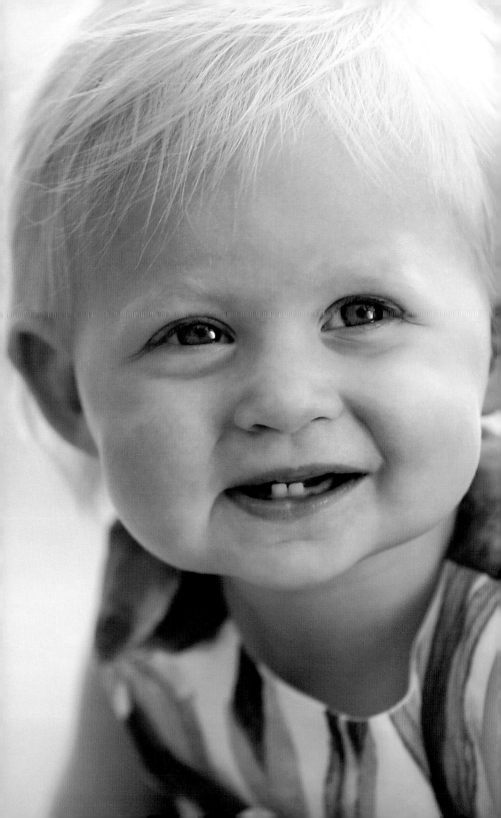

and the mother is lying under the blanket, holding the baby, and she just lifts the baby up, and I take the baby's face. You can do all of this with your assistant or designated photography partner.

When a child is really young, you have to bring the adults to the baby. She has to be laying down, with her face relaxed, and you bring a parent or guardian's face right up next to the baby's face. Or you bring the adults together, right up to the baby.

Here's a posing technique famous portrait photographer Monte Zucker taught me about babies. Tuck one foot under the knee, and then you have her feet and legs posed. Turn her at an angle to your camera, and then you've got a beautifully posed portrait.

Most of the time, a sleeping baby is perfectly beautiful. You can photograph a tiny sleeper in her bassinette, right out of the car.

Tummy time is another source for sweet photographs, and then you can put your baby on her back. In both instances, you'll want to keep the baby's head up. I like to use a baby poser which is like a little puffy armchair that keeps tiny ones supported and their heads up. You can purchase one online.

With posing teens, keep the teen moving and keep changing her pose. Tell her you want her to change the pose for each shot. Variety is a great thing to have when you're looking for the Perfect Portrait, and even older children like to be entertained and mentally occupied by the "posing game."

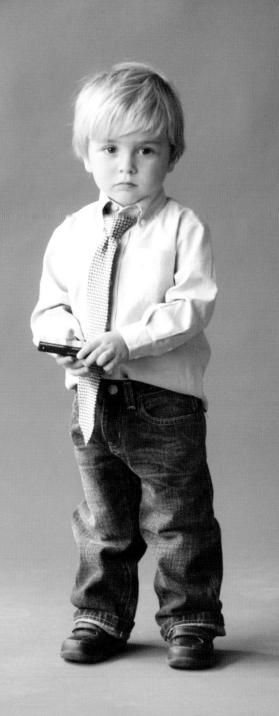

GARB THAT GRABS

CHOOSE THE OUTFITS

We'll talk more about outfits in the last Secret when I cover group photography. But for single baby and child portraits, there are different considerations.

When you're thinking about outfits, start with what you already have. Everyone has blue jeans. Everyone has a white shirt or a dress in a pastel color. Keeping the clothing plain is important.

The only colors not to wear are *red* and *yellow* because these colors will draw the attention away from your subject's face and direct all the attention toward the clothing. With portraits, you always want the focus to be on the face.

So no red and no yellow clothing.

What else? Always dress subjects in solid colors. And I like all the colors you see in nature: green, blue, brown, earth tones.

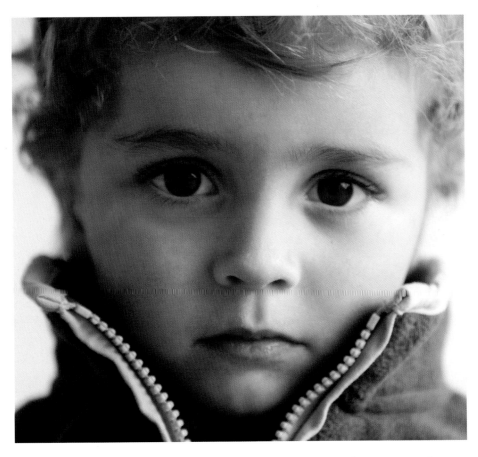

A little girl wearing a sweet dress can make a really nice formal portrait. Jewel tones in an outfit work well with a dark background to create a more formal portrait look.

If you have two children in your photo session, have several outfits for each child, and then lay the outfits out and see which ones go together. This is an easy process if your session is at home or in someone else's house. If it's in a studio setting—hey, you might become such a great Perfect Portrait photographer that you'll open your own business!—then have your client bring a variety of outfits and combinations to the session.

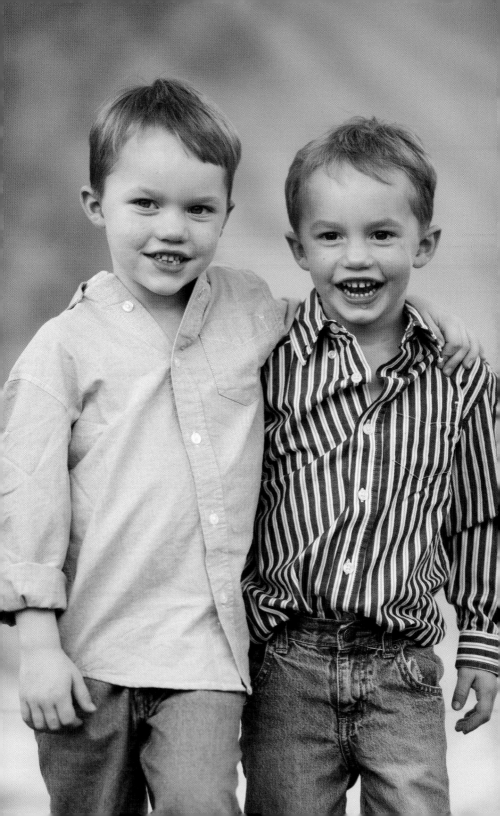

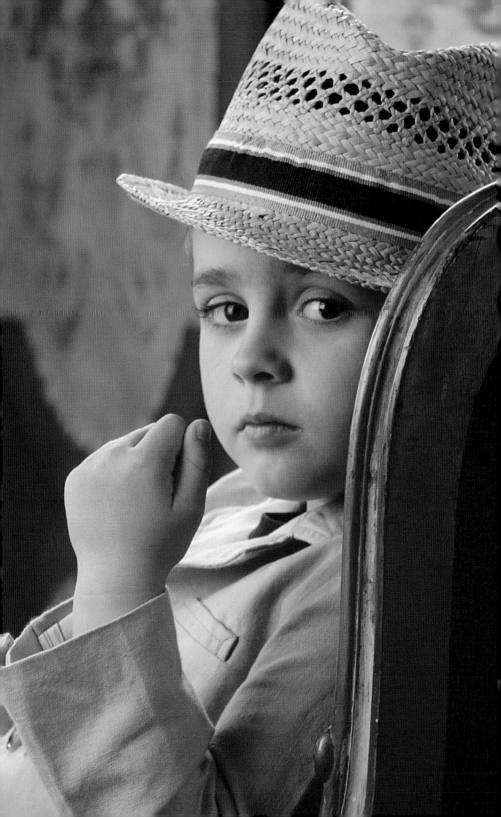

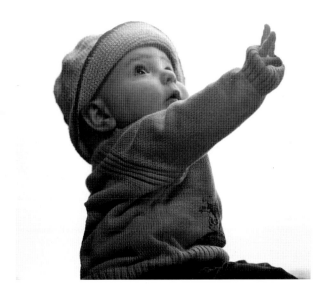

After looking through your camera's viewfinder at your own baby or other people's babies, you'll always come away with the observation that babies have big heads. Don't be the photographer who pastes a tiny little bow on the top of Baby's head, and *never* allow it on any baby's head that you're photographing. It will only draw attention to how big the head is. If you can get a little hat on Baby, then boom—the eyes will go right to the face, where you want the focus to be.

How should you dress Baby for a portrait session? Choose a couple of onesies in pastels and white, avoiding red and yellow altogether.

I try to cover up a baby's skin, to draw the viewer to the face. But then at the end, I'll say, let's try a couple of "nudies," depending on the age of the child. Don't show any of the private parts. Lay the baby on his tummy, and lay a diaper under his private parts because, once you get the diaper off, you're bound to get accidents.

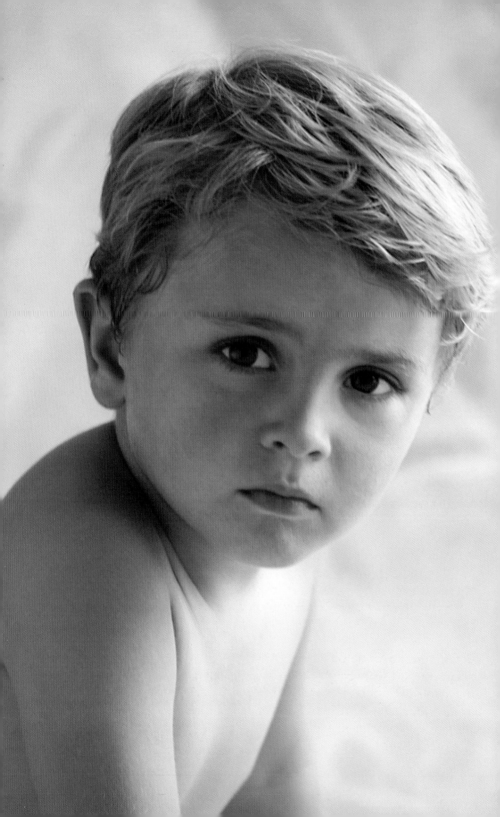

SECRET NO.8
CLEAR THE CLUTTER
CHOOSE THE RIGHT BACKGROUNDS

L et's step back a bit. Before you can do your boldness of attack, before you can start setting up the pose or worrying about the outfits your young subjects will wear, you've got to think about the background. And my watchword here is: Clear the Clutter! One mark of an Amateur Portrait (versus the Perfect Portrait) is that it's taken in a living room crowded with furniture, with toys scattered about and distracting art and accessories on the walls.

That's fine if you're just taking a candid photo of your child playing, or if you're trying to capture a spontaneous moment. But when you really want to go in there and take a great portrait, you've got to set up the background.

I don't want anything distracting in my backgrounds. I want my focus to be completely on my subject, not on whatever's in the background. That's true whether you're shooting outdoors or inside.

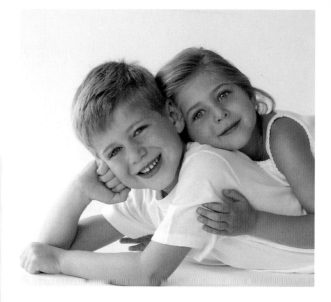

Pointing the camera up toward a bright sky runs the risk of exposure disaster since the camera's meter doesn't know whether the bright sky or the child's face is your intended subject. This is one of the rare times I'll use an on-camera flash to put sufficient light on the subject's face to smooth out the scene. The large aperture throws the tree branches out of focus. If they were sharp, they'd be a distraction.

Indoors, you need to find a wall that's in a neutral color: white, off-white, or a pale color. If you have a painting or other decoration on the wall, see if you can move it, and that may give you enough room to work with. To get rid of the distractions of baseboard or outlets, you can drape the floor with a plain white sheet. And clean blankets can be a nice base for any photograph.

For outdoor portraits, if you have your child sitting up, take a minute to scan the background and make sure there isn't "some big thing"—a pole or a street sign or tree trunks—in the background. If there is, shift the position of the child a little bit.

You can also just get a clean white sheet, lay it down on the ground, and use that as an outdoor backdrop. Kids will love this—it's like they have their own little playground in the park or on the back lawn.

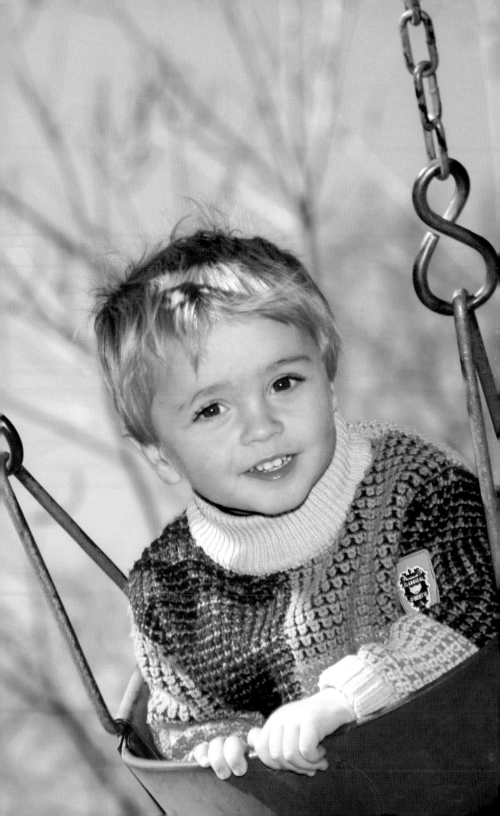

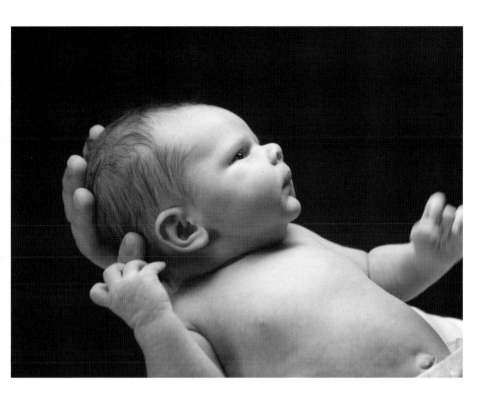

One trick that can work great with kids, especially if you're photographing a couple of siblings, is to put a sheet on the floor, or use a carpet with a plain pattern, and have them lie down flat on the floor.

Kids love doing things like this, because usually Mom is telling them not to!

Then, you set up a ladder or hop on a step stool and hover over them, and photograph them from above. This really gets them giggling, and also gets you some really interesting poses.

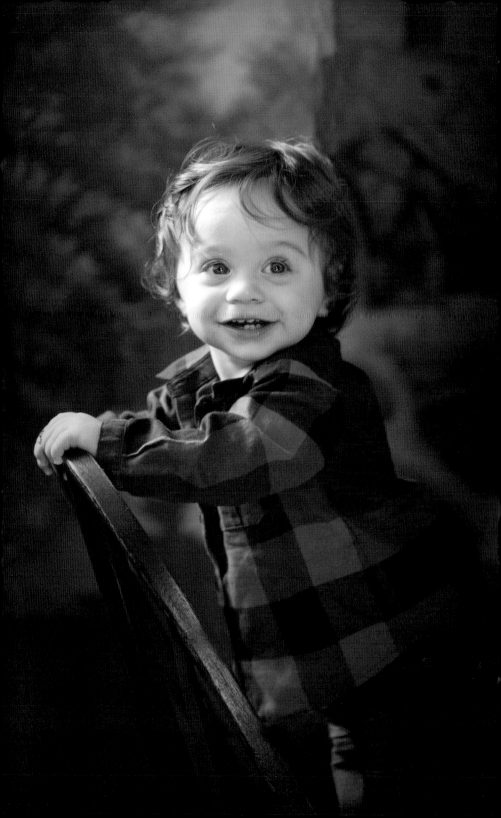

SHINING EXAMPLES

LIGHTING IS KEY

For the Perfect Portrait, you always want to have plenty of light. But here's the exception: you don't want a bright overhead sun f, because that will cast harsh shadows on your subject. Remember this lighting rule:

Perfect Portraits are taken with light that's coming in from the side.

I encourage all beginning portrait photographers to set up their lighting in a room ahead of time using an *adult* model.

You don't want children getting bored or cranky waiting for you to fiddle with lights.

That takes all the attention away from them, and it takes the sizzle completely out of your boldness of attack.

If you don't yet have professional photography lights, you can just work by a big window. Then follow these steps with an adult model to get your setup just right.

- Place your subject's anchor spot—a chair, posing blocks, etc.—parallel to one edge of a large window (your light source).

- Move your model away from the window by a few feet. You want the light to softly shine on your subject. Note that the light will shine on the side of the model's face closest to the window, eliminating all shadows. The other side of the model's face, away from the window, will also have some light shining on it (professionals call this *wrap-around light*), but there will be some shadows there.

- To eliminate the shadows on the side of your model's face away from the window, have your assistant stand on that side of your model and hold up a reflector so that it bounces light back at the window—and also lights up the shadow side of the model's face!

- Once you have the lighting setup you want, take a good look at the lighting on your adult model, adjust it for shadows, and you're ready to take the Perfect Portrait of your young subject(s).

Did you know that a garage can be an excellent way of getting good portrait lighting, too? Set up your studio in the garage, with the garage door wide open, and then you have that good side light coming into your space.

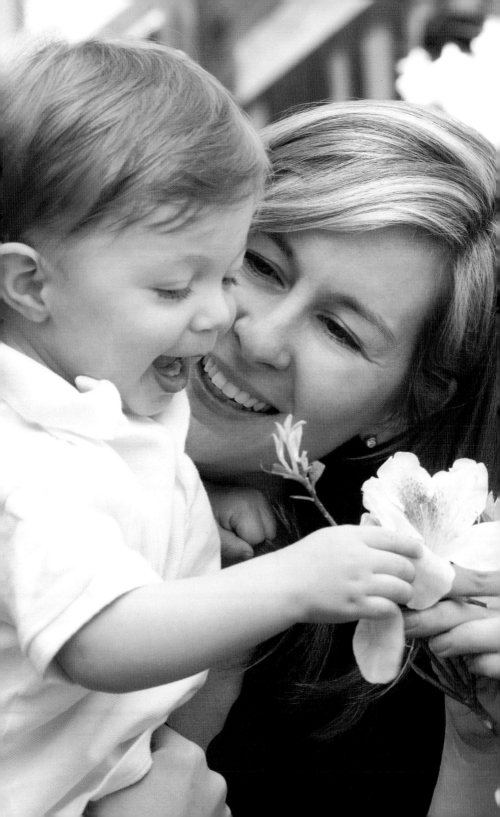

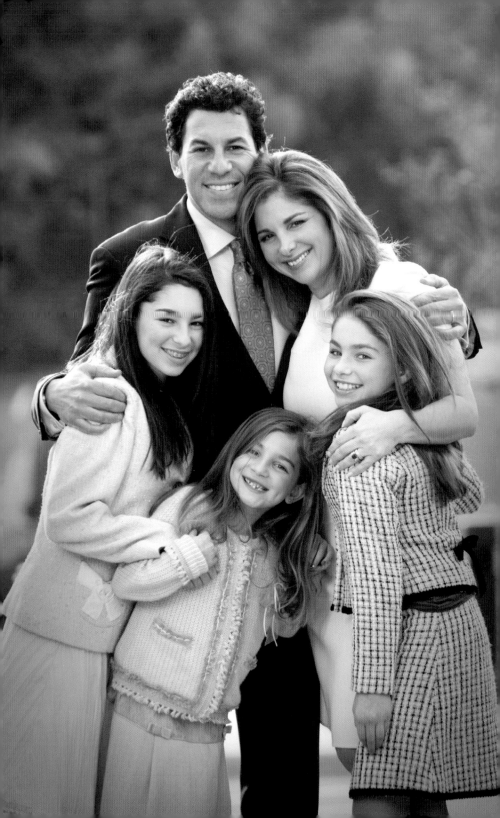

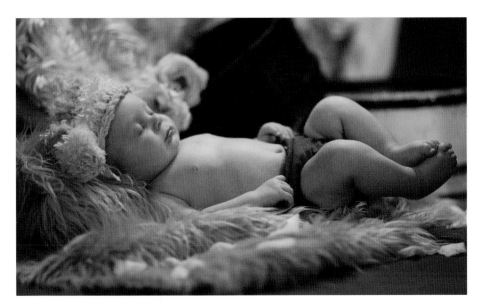

Use the wrap-around lighting technique with the reflector to eliminate shadows on the side of your subject's face that's turned away from the garage door.

To capture the angelic look of a sleeping baby, the key is not having a flash on your camera. Direct light from your flash will wash out the baby's delicate features, and his picture will go completely "flat."

The key is having the light coming from behind or on the side.

Remember our earlier technique from Secret 5 where you get your baby's attention with a whistle, bell, or jangling keys?

It's important that all the props you use to capture your subject's attention—bells, dusters, bubbles—should happen between the camera and the light. And stay on the same side as your light source, which means the baby will look toward the light.

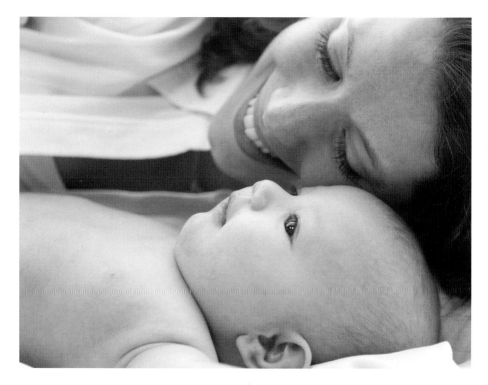

Outdoor lighting is the most difficult, because you've got light coming from everywhere, and you don't have any control over it.

If you're stuck outdoors in bright sunlight, find a shady spot where the light is nice and even—not too shadowy and not too dappled. You can also use the fill-in flash feature on your camera to eliminate shadows.

But the light of early morning and evening is the prettiest, softest light. It will give you a great look for certain outdoor portraits.

If you want to take outdoor portraits, it's good to photograph children in the late afternoon. Bring them outside first, take those outdoor shots, and then come inside for the next round of portraits.

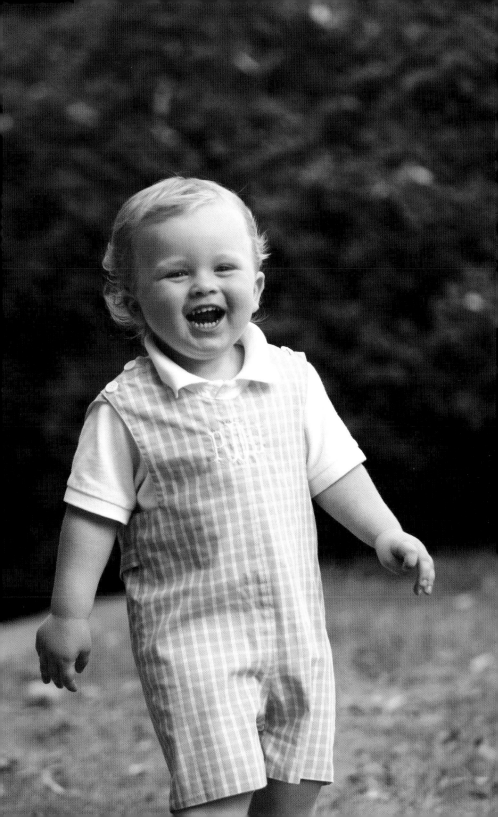

EVERYTHING'S RELATIVE

PHOTOGRAPH GROUPS AND SIBLINGS

You won't always be taking single-subject portraits. You'll eventually want to take Perfect Portraits of siblings, of the entire family, of the entire neighborhood, or of even larger groups. Let's dive into some of my techniques for taking great group pictures.

What can be very distracting in any group photo is if everyone's wearing different colors, patterns, and styles. One person is wearing blue and green stripes, one has a frilly yellow dress on, and another person is all in white.

If you want a really great group or family portrait, have the family lay their clothes out on the bed or the couch before your photo session, and help them build a palette for the whole family. Choose just a couple of colors out of each person's clothes, or if that doesn't work, you can put everyone in black or white shirts and dark jeans.

After everyone's dressed and ready to get their picture taken, it's time to build the *composition* of your group. Translation: you'll need to arrange everyone so it doesn't look like you're photographing an unruly mob scene.

- First, you'll need to build a foundation for your overall composition. Put a core group in the front and center, and then build out from there.

- Place smaller people in the foreground, so the littlest kids are in front. Anchor them on chairs, and then you can form a standing row behind the seated front row.

- If you're photographing an extended family, a lot of photographers think you should put Grandma and Grandpa in front, as this will put them in a place of honor. But please don't—usually the grandparents are heavier, and you want the weight to be in the back of the photo. So always put the children in front.

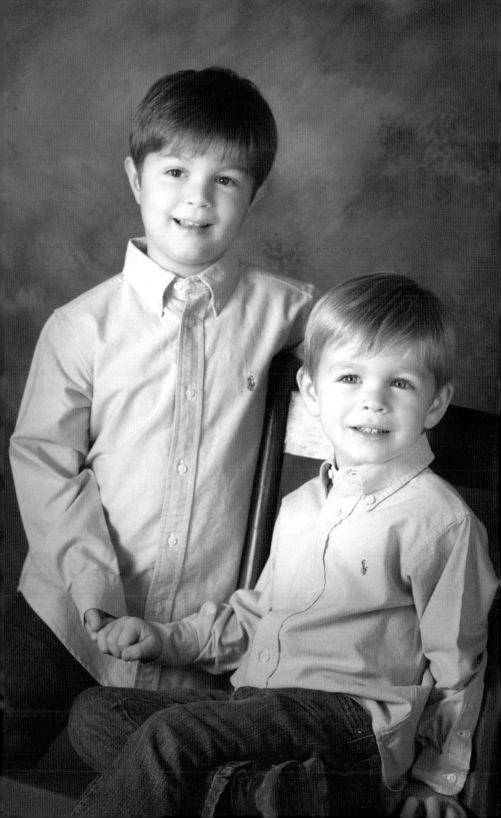

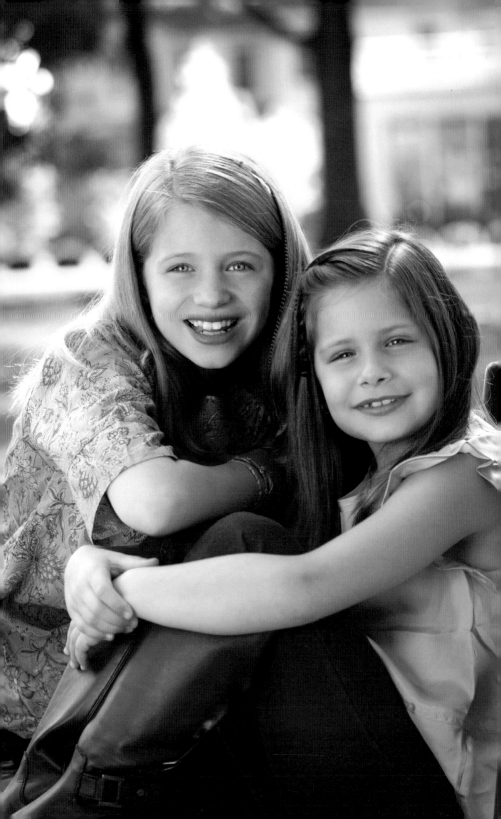

- Then, make sure you have your back row standing close to the seated front row, and have them lean forward so you can see their faces.

You need to look at each person in the photo, and you want the lighting (Secret 9) to be really flat so that shadows aren't cast over everyone's faces.

Now, you're ready to move on to posing (an extension of Secret 6). My posing rules for larger groups of subjects are simple to follow—and the end results are foolproof.

Look at everyone, imagining how they would photograph if you were to cut everyone out of the group photo. Make sure they're properly posed, looking natural, and nothing is out of place. With that attitude that "every person in the composition must look great," for big family or other group photos, look at the first person on the left, then the next, then the next, then the next. Look at each person, left and right, and give quick instructions to each in order to make them perfect.

Keep happy-talking your subjects as you eyeball them from left to right. Continually throw out suggestions for posing improvement. "Ricky, try scooting over just a little closer to your sister." "Roger, the left side of your collar is sticking up … if you could just tuck it back down. Great!" "Aunt Ruth, try putting your right arm around Cousin George. That's it." "Scott, here's a teddy bear. Can you hug him in your lap for me? He needs a friend. Well done!"

All the time you're individually perfecting each person in the group, keep looking at the overall picture.

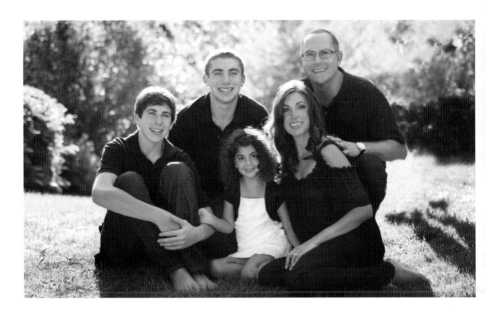

When I take group shots, I'm all about getting the spacing even and natural looking, while all the time making each individual look stand-out great.

When the group you're photographing becomes large in number, your camera level has to go up a bit so we'll see more of the people in the background. Take the picture from ground level, or stand on a step ladder if you want a bit more height.

When you have 15–20 people, you seat a row and you stand a row. If you have 20 people, you seat ten, and you stand ten. With groups of 30 people, climb a ladder to photograph everyone.

If you have 300 people (wow—that would be awesome!), take pictures from an open window on the second floor of a house or other building. Just take the photograph looking down on everyone.

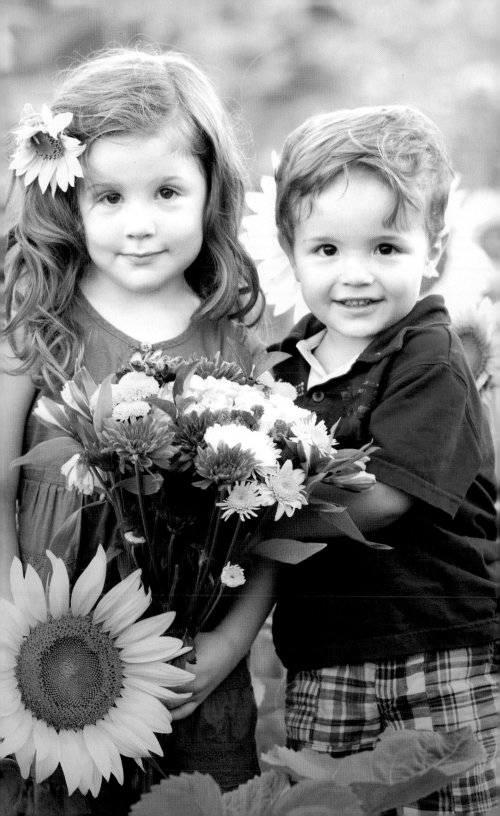

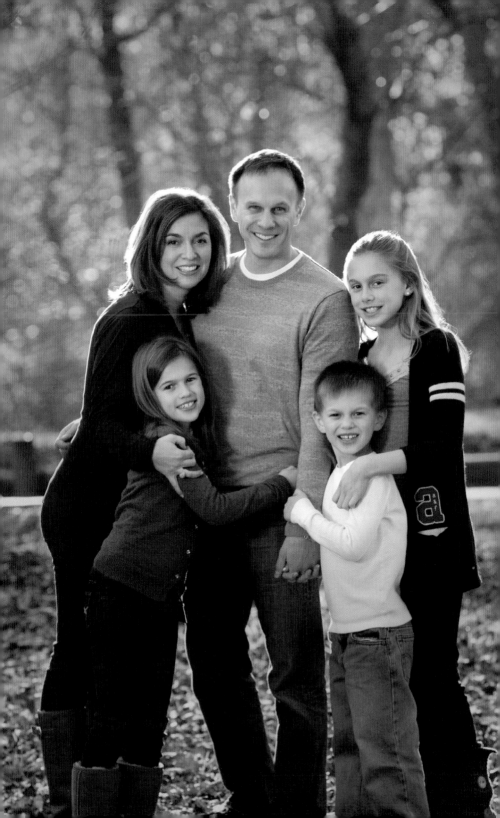

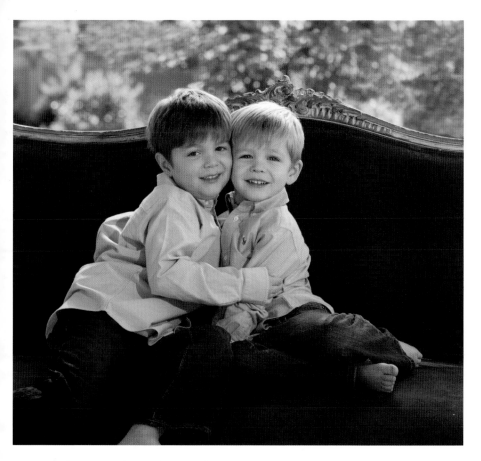

Group photography is fun, and I encourage you to try it. And remember that the procedure is always the same. Get everyone properly dressed for the shoot. Always put the heavy people in back. Put the lighter and littler people in front. Moving left to right, perfect everyone's appearance and pose. Keep the banter going with everyone, and be entertaining. Get the Big Picture and make the overall group's spacing even and natural.

Use really "flat" lighting, holding the light right over your camera.

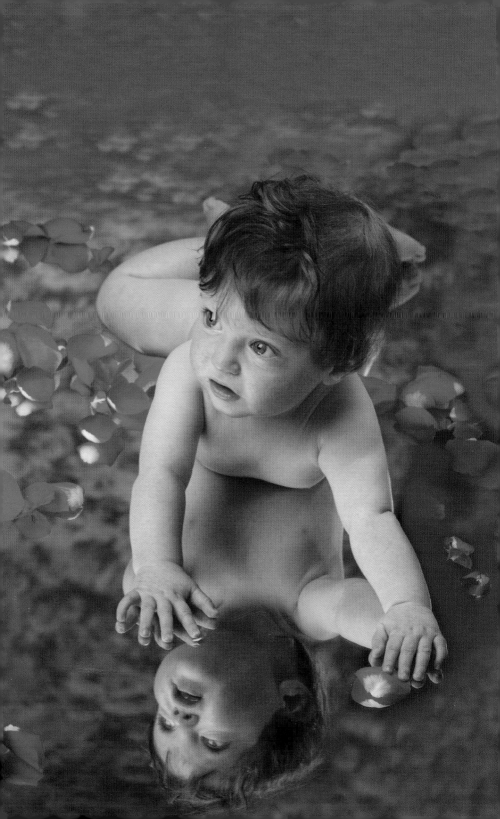

PERFECT PORTRAIT POINTERS

BEYOND THE SECRETS

You now have my Top Ten Secrets for Perfect Baby and Child Portraits—and you can apply most of these portrait tips to photographing your child when she grows up and becomes an adult … although you'll probably want to abandon those attention-getting Silly Dilly tips!

The truth is, as a professional photographer photographing complete strangers all day, I'm trying to win over the child by being his or her friend. Children are small people, and they should be treated as adults when you're photographing them. Even at an early age, children can tell *immediately* and *instinctively* whether the photographer likes them or not.

You have to love babies and children to photograph them well, and please remind yourself constantly that you're starting with a great advantage: you're photographing someone you love very much! All the Secrets in this book, however, will come in handy when you're photographing little ones that don't

Do you have some Perfect Portraits you'd like to share?

Visit me and the New York Institute of Photography at *www.nyip.com /Everyday -Photography* to share your baby, child, and family portraits—and everything you've learned in this book—with me and the rest of the world.

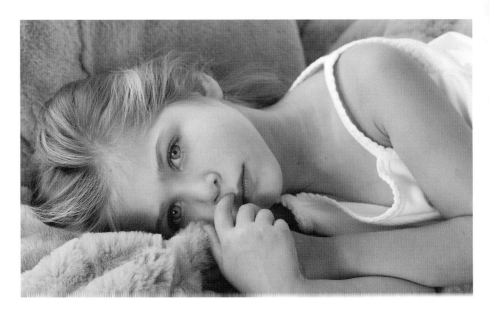

have that close bond and family relationship with you that your own children have.

For a professional photographer, it's important for me to gain a growing child's confidence. After three or four years, when a child reacts to almost anything, I can tell a young boy how glad I am to see him because "I've had to photograph so many girls lately—it's good to photograph boys now!"

Right away, the boy is flattered and feels wanted.

On another occasion, I'm happy because I have a little girl to photograph, and I tell my subject, "Girls are so much more graceful and have such pretty clothes!"

The young girl then feels that she's in the hands of a friend who understands her and doesn't particularly like boys … which suits her fine.

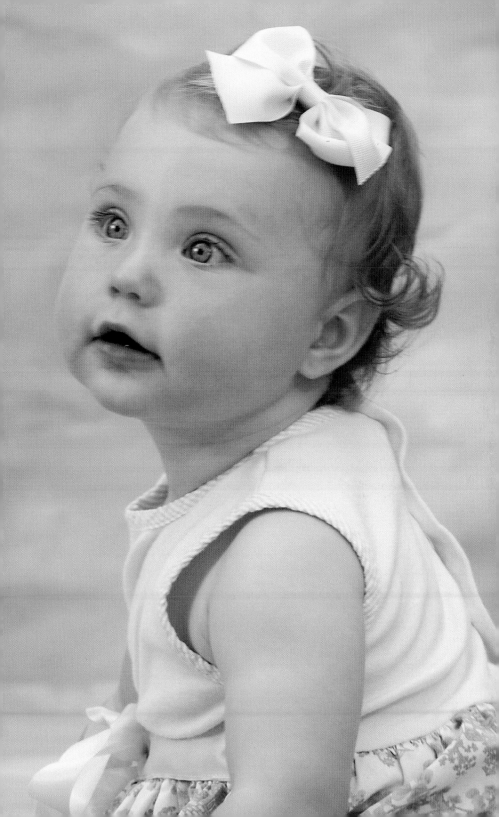

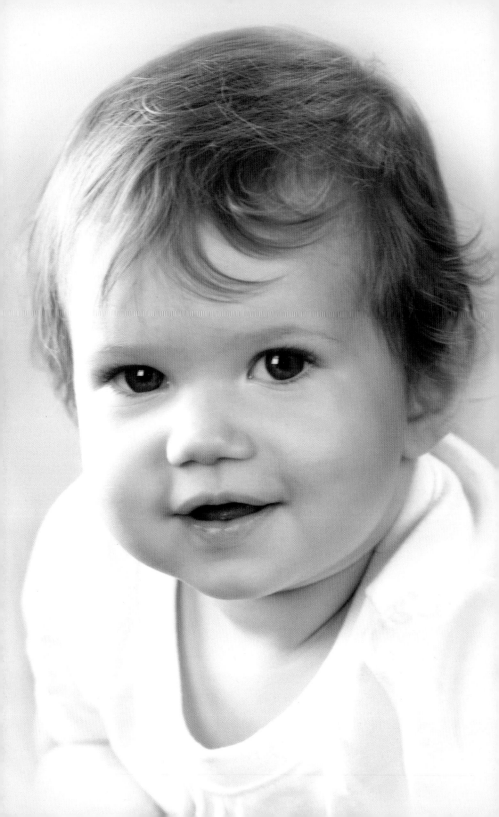

Let me leave you with a few technique reminders and parting thoughts.

- When you want to make your child look happy or try to coax a smile, you must maneuver into the expression by joking at the child's level. The joke should always be on you, the photographer, and never on the child. If the toy monkey you're holding "sneezes," he should sneeze on you, not on your child.

- I go into photographing children with a boldness and intensity that's in my heart—however on the outside, I look cool, calm, and collected. My mood is "soft."

- There should be many techniques at hand and a host of mental strategies in your head for you to gain your subject's immediate attention. Often I feel like I'm in a chess game waiting for the child to move, but all the while, I have my next three moves figured out. So think ahead, and be prepared.

- Any photographer must establish a rapport with young subjects, just as with adult subjects. The following tips have really worked well for me.

 - During the photo session, talk and act like a child—and even sometimes act silly—to gain your child's confidence while taking his picture.

 - All the while, you must keep command of the photography session. If your child responds poorly to one approach, smoothly and swiftly change his attention to something different, no matter how illogical.

 - Keep your child's attention on external things other than himself.

 - Wherever possible, eliminate onlookers and bystanders, including grandmothers and aunts. Your partner or assistant should be near enough to reach out and touch your subject immediately, but then slowly slip into the background as the session unfolds.

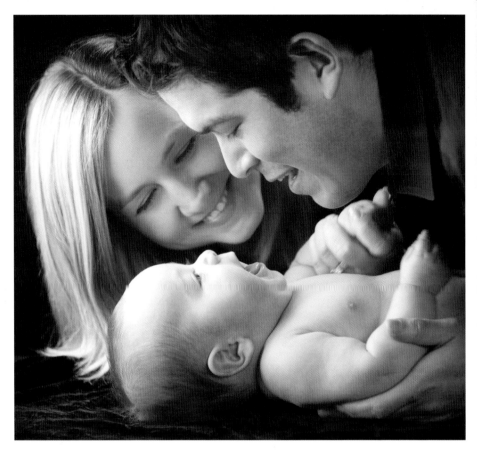

As a parent, grandparent, or guardian, you should never be satisfied taking any old picture.

If the portraits you photograph showcase your child's personality—the window into your child's inner self—they'll be much more important and valuable to you and your family.

That's my hope with this book, that you'll use the secrets of taking the Perfect Portrait to build a treasure trove of keepsake images that will be cherished by your family and friends for generations.

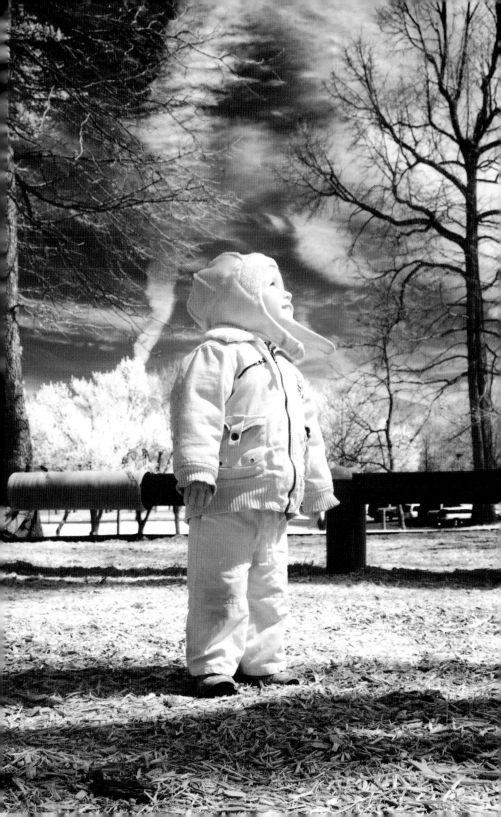

INDEX

BONUS VIDEO

Watch photographer Clay Blackmore in action. Go to *www.nyip.com/Everyday-Photography* to watch him demonstrate some Secrets.